Italian Illuminated Manuscripts

IN THE
J. PAUL GETTY
MUSEUM

D1273528

Italian Illuminated Manuscripts

IN THE
J. PAUL GETTY
MUSEUM

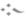

Thomas Kren

Kurt Barstow

THE J. PAUL GETTY MUSEUM
LOS ANGELES

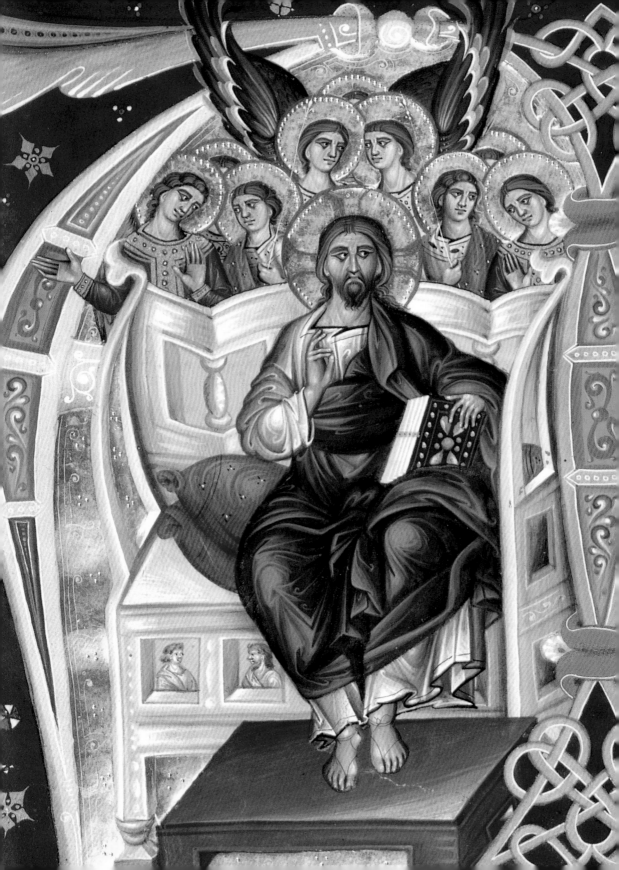

FOREWORD

Manuscript illumination constitutes one of the Getty Museum's seven main collecting areas, the others being Greek and Roman antiquities; European paintings, drawings, sculpture, and decorative arts from the period before 1900; and European and American photographs from the nineteenth century to the present. The Museum's manuscripts range in date from the ninth century, during the Carolingian era, to the sixteenth century, and so vividly represent a significant chapter in the history of European painting from the Middle Ages to the Renaissance.

This volume, dedicated to our collection of Italian illumination, is the first in a series intended to introduce our holdings of illuminated manuscripts, by region, to a general audience. While Italy is still modestly represented in our manuscripts collection, we have steadily pursued the acquisition of Italian manuscripts, leaves, and cuttings since the early 1980s and have made great strides in recent years with the acquisition of a number of important works. Italian manuscripts are especially significant as a complement to the Museum's holdings of early Renaissance paintings, because so many artists from the thirteenth century on worked as both painters and manuscript illuminators.

I would especially like to thank Thomas Kren, Curator of Manuscripts, and Kurt Barstow, Associate Curator of Manuscripts, for their vital contributions to the development of the collection, as well as for compiling this volume. Kristen Collins, Chris Allen Foster, Michael Smith, and Stanley Smith helped us to assemble an outstanding group of transparencies and digital files for reproduction on extremely short notice. I am also grateful to Vickie Karten, Ann Lucke, Amita Molloy, Karen Schmidt, and Deenie Yudell, who joined forces to produce another handsome volume about the Getty collections.

William M. Griswold
Acting Director and Chief Curator

INTRODUCTION

The J. Paul Getty Museum's collection of Italian manuscript illuminations is the youngest institutional collection in the United States. It was begun in 1983 through the purchase of the illuminated manuscripts collection formed by Peter and Irene Ludwig between 1958 and 1980, a comprehensive holding of European manuscript illumination that covered the ninth to the twentieth century and many of the great medieval and Renaissance centers of book painting. This holding included a range of Italian illumination over eight centuries, and it included such masterworks as the Benedictine breviary from the Abbey of Montecassino; the Bolognese antiphonal by the Master of Gerona; the Ferrarese Gualenghi-d'Este Hours, illuminated by Taddeo Crivelli; and the Roman gradual illuminated by Antonio da Monza for Santa Maria in Aracoeli. To this solid foundation, the museum has added selectively, for the most part with single miniatures and cuttings, due to the exigencies of the marketplace. Additional purchases bring the total of works to forty-four and have helped to make the collection more representative of the extraordinary achievement of the Italian tradition of illumination. Among the high points acquired since the purchase of the Ludwig Collection are Girolamo da Cremona's *Pentecost* (p. 44); a large decorated initial from the Santa Maria degli Angeli choir books in Florence (pp. 38–39), which was designed by Lorenzo Monaco and carried out by assistants of Fra Angelico; an initial with *The Conversion of Saint Paul* designed by Pisanello (see opposite and p. 42); and a missal once owned by the antipope John XXIII, the finest book from the Bolognese period of the Master of the Brussels Initials (pp. 22–27).

It must be said that collectors, including those well outside of Italy, have long coveted Italian illumination, certainly from the time of the great Renaissance Hungarian bibliophile Matthias Corvinus (1443–1490). The distinction today

of the Italian manuscripts holdings of the Bibliothèque nationale de France rests significantly upon manuscripts that Charles VIII (r. 1483–98) carried off from Naples and upon the great libraries that Louis XII (r. 1498–1515) brought back with him from Milan in 1499. European admiration for Italian illumination only grew over the centuries. Collectors from the United States did not become seriously involved in purchasing Italian manuscripts until the end of the nineteenth century, but they have collected aggressively since then. (The aforementioned missal owned by the antipope John XXIII, it should be noted, came into the hands of a Chicago collector by the 1880s.) Certainly in the forefront of the Americans was J. Pierpont Morgan (1837–1913), the powerful financier, voracious art collector, and bibliophile. His library, ameliorated by his heirs and successive generations of Morgan Library staff members, was made public in 1924. It contains by far the finest and most comprehensive collection of Italian manuscript illumination in the country. But Henry Walters (1848–1931), better known for his French books of hours, also collected Italian manuscripts, which are now in the Walters Art Museum, Baltimore. In the first half of the twentieth century, the New York Public Library built one of the finest of the American collections of Italian manuscripts, with special strengths in Renaissance material.

Always important for aficionados of Italian illumination, especially since the nineteenth century, has been the availability of leaves and cuttings removed from Italian books. A famous sale of cuttings from papal manuscripts was organized in 1825 by Abate Luigi Celotti in London. The works were allegedly removed from manuscripts brought back from Italy as war booty by Napoleon's troops. A hundred years later William Milliken (1889–1978), the director of the Cleveland Museum of Art from 1930 to 1958, observed that he could represent Italian regional styles of illumination in a cost-effective way in his museum by purchasing manuscript cuttings, a practice that led to the formation of a significant body of later Italian illumination. Many other American museums have acquired, usually by gift and in the form of cuttings and leaves, one or more exceptional examples of Italian illumination, including the Metropolitan Museum of Art, the National Gallery of Art, the Saint Louis Art Museum, and the Nelson-Atkins Museum of Art, among others. By the 1980s,

due to centuries of avid collecting, outstanding Italian leaves and cuttings, although rarely on the market, were more likely to become available than an exceptional Italian manuscript.

Some other libraries with collections of Italian illumination include the Free Library and the Rosenbach Museum and Library of Philadelphia, the Lilly Library at Indiana University, and the Houghton Library at Harvard. Unfortunately, many of the aforementioned holdings, with perhaps the notable exceptions of the Morgan Library, the Free Library, and the Houghton, are poorly known. This small volume endeavors to make known the current shape of the Italian illumination collection at the Getty Museum. The effort to build holdings that are truly representative is still in progress.

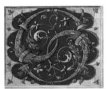

While manuscripts are integral to the cultures from which they sprang, in that they align with the general stylistic trends that define art-historical periods and reflect the shifting social circumstances and important historical events of their times, they are also unique types of objects with their own tradition. The manuscript illumination in this volume spans seven centuries, representing a dramatic evolution of visual styles. Although it begins with objects produced in monastic scriptoria and ends with missals produced by secular artists, there is still a family resemblance among all these works. For whether they depict scenes from the life of a newly popular saint, such as Saint Dominic or Saint Francis, or are products of the Italian fifteenth-century retrospective movement known as Humanism, or are recognizable examples of the schools of Renaissance painting styles peculiar to Florence and Padua in the fifteenth century or Rome in the sixteenth century, all these illuminations were originally in books and therefore viewed within the context provided by words, prayer, and ritual. Not only

can some of the works included here be counted among the finest and most creative examples of Italian painting, all of them — from illumination in saints' lives to fighting manuals, from books made for private devotion to those made for public ceremony — extend our conception of the range, contexts, and meaning of visual imagery within Italian culture, especially the later periods of the fourteenth through the sixteenth century, where our sense of the period's painting has been informed almost exclusively by monumental frescoes, as well as by panels.

 The earliest medieval examples included in this volume may most closely meet one's expectations about manuscripts and their makers. They are a leaf from a psalter and a breviary, the two books most important for the daily round of monastic devotions, decorated with large interlace initials marking the beginnings of important texts. The sacred word is here embellished, humbly in the ninth-century psalter page (p. 1), which contains the hymn ascribed to Saint Ambrose and Saint Augustine, "We praise you, O Lord" (Te Deum laudamus), and more ornately in the twelfth-century breviary made in Montecassino, the heart of Benedictine monasticism (pp. 2 – 6). Just as the word must be considered in these works as something visual, to be seen as well as heard, visual imagery in manuscripts must be perceived within an oral and textual framework that informs its meaning and reception.

 We might examine, in terms of relationship between text and image, two nearly contemporaneous illuminations that portray the two most important founders of new monastic orders in the thirteenth century, Saint Dominic (about 1170 – 1221), who founded the Order of Preachers (Dominicans), and Saint Francis (1181 – 1226), who founded the Order of Friars Minor (Franciscans). The initial M with the Death of Saint Dominic (p. 8) comes from a Bolognese choir book and accompanied the text that would have been sung on the Feast of Saint Dominic. The visual marker of this chant is a complex of layered imagery rather than a single narrative event. First of all we see Saint Dominic on a funeral bier with members of his order gathered around. Above, his soul (represented as a small figure of Dominic) is pulled up into heaven by Christ and the Virgin, the part of the scene that derives from a vision of one of the early Dominican brethren, Fra Guala of Brescia. Below, we see the infirm gathering around the body of Dominic, a scene meant to convey the miraculous

healing powers of the newly deceased saintly remains. And, finally, in four roundels at each corner, Dominican friars are seen in different gestures of prayer. These figures may represent the contemporary audience — the Dominican friars who used the choir book and sang praise to their founder on his feast day. Likewise, the initial G with the Stigmatization of Saint Francis (p. 9) by Rinaldo da Siena complements the text for his feast day. The story related is the moment when Francis, meditating on the Crucified Christ, has a vision of Christ on the cross surrounded by seraphic wings and is so moved that his body takes on the very wounds (stigmata) of Christ. The vision itself is cleverly integrated into the letter, for it seems to originate from three blue bands that disappear behind the middle section of the letter, while the wings overlap the front of the letter. The birds deployed around the saint are meant to make reference to the famous story of Saint Francis preaching to the birds, but they also seem disturbed, some of them ruffling their feathers as if they have noticed the apparition above. Their attentiveness to Francis and this event also reminds one of the first word of the chant "Gaudeamus" (Let us give praise).

Another example of this sort of context in a choir book from this period may be seen in one of the finest miniatures in the collection (pp. iv, 13). In the Initial A with Christ in Majesty, also from a Bolognese choir book, the Master of Gerona uses a number of means to create an especially forceful, dynamic physical presence of Christ, from the crowded angels bursting out of the letter form, to Christ's crisply modeled robe and piercing gaze, to the projecting footstool in front of the sculptural throne. The text of the chant, as it happens, is devoted precisely to the physical presence of Christ in the world. The miniature complements the first long chant sung on the first Sunday of Advent, the season of preparation for Christmas. It uses words from Isaiah (the prophet pictured in the roundel below), "Aspiciens alonge" (Behold, from afar I see the coming power of God), which were also thought to foretell the Second Coming of Christ.

Manuscript painting in Italy was shaped not only by its particular context within a book but also by diverse regional traditions and differing circumstances of production. In the medieval period, more specifically the thirteenth and fourteenth centuries, Bologna became both a major university town and an important center for

the Dominican order (Saint Dominic is buried there). Thus it also became a major center for the making of manuscripts, especially books for scholarly study, but also those associated with the Dominicans. The latter is exemplified by the cutting from a choir book discussed above (p. 8) and also by an elegant Bible with playful marginalia that includes within its initials Christ, the appropriate biblical authors for each section, and Saint Dominic or some other Dominican, making apparent the transmission of spiritual knowledge from the time of Christ down to the era of the Dominicans (pp. 10–12). Bolognese illumination continued to thrive in the fourteenth century, which witnessed a new, exciting, almost restless style, practiced distinctly by several artists. A miniature (p. 21) teeming with activity — a grape harvest, collecting nuts from a tree, milking a cow, crushing grapes — illustrates a section discussing agriculture in Justinian's *New Digest,* an important textbook of Roman civil law codified originally in the sixth century.

The greatest illuminator of this period was Niccolò da Bologna, whose massive but sensitively painted Saint Dominic decorates a folio from a register of the Shoemaker's Guild (p. 28). All the guild members from the neighborhood of San Procolo are listed next to the figure of the saint, with notations made next to their names as they died. A more exuberant scene of the Pentecost, an initial from a choir book (p. 29), provides us with an example of Niccolò's lively, compacted narrative imagery. The most significant manuscript from this period in the collection, however, was illuminated by a student of Niccolò's known as the Master of the Brussels Initials. This artist began his career in Bologna and later moved to Paris, the other great university town of the day. While still in Italy, he was employed to illuminate a missal (pp. 22–27) for Cardinal Cosimo de' Migliorati, who later became Pope Innocent VII. The manuscript was subsequently owned by the antipope John XXIII, whose arms and papal tiara are painted over the original arms. The illumination in this manuscript is notable for the exceptional inventiveness of the marginalia and its animated scenes, but it is also worth commenting on the creative use of gold. In the Christ in Majesty (p. 24), the foliate background, the halos of Christ and the angels, and the rays between Christ's body and the mandorla in which he sits not only activate the scene but also help define the different planes in which the various parts

of the picture are located. In the Elevation of the Host (p. 25), gold helps to register the ceremonial richness of the liturgy. Because the stars in the vaults are all done in gold, real light catching them on the page makes them shimmer, just as they must have in the vaults of contemporary churches.

Artists in Florence and Siena did not tend to specialize as their counterparts did in Bologna. Indeed, almost all the illuminators represented in Florentine or Sienese manuscripts from the collection practiced in other media as well. The Master of the Dominican Effigies (pp. 18–19), Lippo Vanni (p. 20), Lorenzo Monaco (pp. 38–39), the Master of the Osservanza (p. 40), and Giovanni di Paolo (p. 41) were all panel painters as well. And the most prolific of these illuminators, Francesco d'Antonio del Chierico (pp. 56–57, 60–61), was also a goldsmith. The Pentecost by the Master of the Dominican Effigies (pp. 18–19), with its brilliant array of colors — from intense lime greens to several shades of blue — and projective architectural tabernacle, comes from the most important choir book commission of the first half of the fourteenth century, the Laudario of the Company of Sant'Agnese. This company consisted of pious laypeople who met as a group to sing and worship together in Santa Maria del Carmine, the church where Masaccio was much later to paint the famous Brancacci Chapel. A miniature (p. 38) from another famous choir book, a gradual made for the Camaldolese monastery of Santa Maria degli Angeli, presents an interesting case, for the scene was designed by the most talented illuminator/painter of the late medieval school of painting in Florence, Lorenzo Monaco, and was finished by artists in the circle of Fra Angelico, one of the most innovative artists of the early Renaissance. Emblematic of the distinctions between the two periods within the miniature are two figures, that of Christ, whose robe is constructed as if it has been cast in bronze by an artist imbued with the aesthetics of the International Gothic, and that of the angel directly to his left, whose upright bearing and clearly defined ringlets of hair are characteristically Renaissance.

Only two manuscripts (pp. 56–57, 58–59), however, both made in Florence, might be called Humanist in the strict sense of that word, Caesar's *Commentary on the Gallic Wars* and Lactantius's *Divine Institutions*. Both are ancient texts of the sort Humanist scholars were interested in; both contain Roman

capital letters and Humanist script, which was derived from Romanesque manuscripts and, ultimately, from Carolingian manuscripts that were thought to be ancient; and both contain the "white vine" border decoration that was imitated from earlier manuscripts and was also thought to be from antiquity.

Another group of manuscripts was produced in the courts of northern Italy or by illuminators who worked at those courts, often moving between them. Expressive of the chivalric ethos of those courts is a manual on combat, *The Flower of Battle*, one of several versions of a manuscript produced for the marquis of Ferrara, Niccolò III d'Este (pp. 33–35). This is a training manual that describes the moves and countermoves that would be made during different combat situations and with different weapons. While the drawings that accompany the text are not exceptional for their artistic quality, they are very interesting for their attempt to convey to the reader/viewer the specificity of tactical maneuvers in the field. One of the great artists to express in visual terms the courtly chivalric splendor that so enthralled the ruling princes of Italy was Pisanello, who worked for the Visconti in Milan, the Este in Ferrara, the Gonzaga in Mantua, and the Aragonese rulers of Naples. A miniature partly executed by him, originally in a choir book and illustrating the Feast of the Conversion of Saint Paul, depicts Paul, clad in Renaissance armor, falling off his horse on the way to Damascus (pp. vi and 42). In the top half of the initial, however, a prince, wearing a flamboyant red cap of the sort then in fashion, is shown with a small retinue of soldiers. The colors of the soldier's plume and the prince's cape can be associated with the heraldry of either the Este or Gonzaga families, both of whom were patrons of Pisanello. The reason for this prince's appearance in a putatively sacred scene is not yet known. He was probably the patron of the manuscript to which this cutting belonged, and perhaps the date of the Feast of the Conversion of Saint Paul held some special significance for him.

Three of the artists that might be considered under this grouping of court illuminators — Taddeo Crivelli (pp. 48–49, 51–55), Franco dei Russi (p. 43), and Girolamo da Cremona (p. 44) — all worked on one of the most lavish and expensive manuscript commissions of the fifteenth century, the Bible of Borso d'Este (Modena, Biblioteca Estense). The Ferrarese Crivelli and Franco dei Russi were the heads of

the project, and the younger Girolamo was brought in later. Crivelli's masterpiece on a small scale, the Gualenghi-d'Este Hours (pp. 49–55), was made upon the occasion of the marriage of Orsina d'Este, a member of Ferrara's ruling family, to Andrea Gualengo, a senior adviser, diplomat, and member of a long-standing family of councillors to the Este. Crivelli's art is dependent in many ways on the two greatest court artists of the fifteenth century, Pisanello and Andrea Mantegna. Despite their diminutive size of just over four inches, the folios in the Gualenghi-d'Este Hours are large in invention and energy that is expressive of their devotional content.

After working on the Bible of Borso d'Este, Girolamo da Cremona was recommended to the Mantuan court by its newly appointed artist, Mantegna. The itinerant Girolamo's Pentecost (p. 44) was likely made during this Mantuan period, for it closely resembles, in feeling and format, paintings executed by Mantegna for the Gonzaga Chapel. Here the Pentecost takes place in the stilled and majestic setting of a Renaissance palace with contemporary window frames and book bindings. And the Holy Spirit — the dove suspended in the middle of the room — casts a supernatural gold light, which bathes the wall and contrasts with the light of the world seen through the window, where an ordinary bird is perched on the branches of a decorative bush.

Lombardy, the province that was largely under the rule of the dukes of Milan, maintained its own artistic traditions, rather more conservative for much of the fifteenth century than the new Renaissance styles of Padua and Florence. A charming, courtly example of Lombard illumination at the turn of the century may be found in the little booklet relating the story of two local saints, Aimo and Vermondo. In one scene we see the two youths, dressed in refined, costly costume, hunting boars (p. 30). The two are saved from the boars by the Virgin and end up founding a church, performing miracles, and developing a cult following. By the time of their death, they were regarded as saints. A second folio from the book shows, above, their new saintly status in a funeral procession, and below, the poor, sick, and infirm gathering at their tomb to pray for assistance (p. 31).

Even at midcentury the art of the Olivetan Master, one of the major shapers of the Lombard tradition, was still imbued with the graceful ideals of the

International Gothic. His Four Saints in an Initial B, a cutting from a choir book, contain figures with elongated hands and faces and voluptuous robes that curve around in calligraphic decoration (p. 62). The subtle distinctions in gesture and facial expression of each individual saint, combined with their tightly knit identity as a group, make this miniature one of the master's most intimate and moving. The Master of the Murano Gradual likely worked under Belbello da Pavia, the major artist of the famous Visconti Hours (Florence, Biblioteca Nazionale), although he later worked in the Veneto. His Saint Blaise (p. 63) is a remarkable study in contrasts. On the one hand, the saint's face is craggy, sharply defined, almost world-weary in its penetrating expression. On the other hand, his powder blue robe and the delicate sgraffito work in the gold ground in their prettiness and refinement seem to belie the harsher realities of a saint who was martyred with a wool-carder's instrument.

The two miniatures by Bartolomeo Rigossi da Gallarate (pp. 64 – 65), made for a Carthusian choir book perhaps originally in the collection of the Certosa of Pavia, are not so different in style from the Olivetan Master's miniature . Facial types are similar, and the hands do much of the work of communicating interior states of mind. Particular to Rigossi, however, is the dramatic play of color and light. The foreground of rose and blue in both, as well as the aggressive lemon yellow of the rock in the Women at the Tomb, lends the miniatures an unreal quality. At the same time the soft, subtle play of light on the hills in the background of both miniatures is obviously based on observation.

Lombard art changed when Leonardo came to the Milanese court, and this is registered in the art of the illuminator called Master B. F. In his Initial D with Noah Directing the Construction of the Ark (p. 71), the facial types reflect the painting of Leonardo. The loose, painterly handling of this scene marks a dramatic change from the world of the Olivetan Master and Bartolomeo Rigossi, introducing a new artistic direction in the sixteenth century.

In the sixteenth century Rome became a significant center of artistic patronage, inspiring a number of illuminators to relocate there. Of the Getty's small holdings in sixteenth-century Italian manuscripts, three of the four are Roman. The great choir book, and largest book in the collection, illuminated by Antonio da Monza, a Milanese artist, was made for the Franciscan church of Santa Maria in

Aracoeli, which sits atop the Capitoline Hill, overlooking the Roman Forum. The most magnificent page from this manuscript, adorning the chant for the Feast of the Resurrection (pp. 72–73), is in many ways a product of the artistic vocabulary of the High Renaissance applied to sacred subject matter. The type of Christ, both in the initial and at the bottom of the page, is derived from Leonardo, as are the winged putti. The decorations in the letter and borders include antique cameos and jewels, as well as a type of motif known as *grotteschi,* drawn from the recently excavated Golden House of Nero. Indicative of the confrontation between the Classical and the Christian is the pairing of Saint Sebastian, studded with arrows and seen through glass in the arm of the letter R, with a cameo of Apollo below. The same heroic body type is employed in both figures, as well as in the central figure of Christ rising from his tomb.

Matteo da Milano, also an artist originally from Milan, worked for many of Italy's ruling families, including the Medici and the Este. By the second decade of the sixteenth century he was in Rome working on manuscript commissions for popes and cardinals. A missal made for a member of the Orsini family (pp. 74–76) contains borders of jewels, cameos, and hybrid figures in an *all'antica* style, a trademark of Matteo's manuscripts. Characteristic of his precise painting and taste for exotic costume is the figure of King David (pp. ii and 76) emerging from the letter A that begins the text for the first Sunday of Advent, "Ad te levavi" (I lift up my soul to you, my God), words from one of the psalms of which David was thought to be the author. Finally, the Christ of the Crucifixion (p. 77) that once belonged to a missal probably made for Pope Paul III and painted by the papal illuminator Vincent Raymond adopts the bulky, heroic male nude type of Michelangelo and sets the cross in front of an extensive landscape. Surrounding this recognizably Renaissance image are fragments of the text for the Exultation of the Holy Cross (at top: "You who suffered for us, O Jesus Christ, have pity on us"). No less than the earliest decorative imagery we have examined in medieval manuscripts, figural imagery in this Renaissance illumination is not viewed in isolation but filtered through the context of words.

While Italian manuscript illumination is less known than other genres of painting, it greatly contributes to our understanding of Italian art in the Middle Ages

and Renaissance. For the earlier medieval periods, it is often the most important example of the history of painting that we have. For later periods, it is a useful complement to what we do know of that period's painting. It should also be remembered that even in the Renaissance, manuscript illumination was very highly valued relative to other sorts of painting. The Bible of Borso d'Este, mentioned above, for example, cost much more than the astrological frescoes in the Palazzo Schifanoia in Ferrara. Manuscripts help to round out our picture of a period because of their widely varied use and the context in which they place images: in the liturgy, in private devotion, for study, for pleasure, for propaganda. Works of history, religion, music, myth, hagiography, literature, archaeology, philosophy, and science were all occasionally decorated with manuscript illumination. And sometimes, because of the requirements of a text, manuscripts provide us with subject matter that is not to be found in other sorts of painting. There are more extensive cycles of the Bible and the *Aeneid* in manuscripts, for example, than in any other painting medium. Thus the study of manuscript illumination has implications for how imagery was used and understood by contemporaries and contributes to our larger understanding of the period's visual culture.

Thomas Kren
Curator of Manuscripts

Kurt Barstow
Associate Curator of Manuscripts

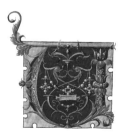

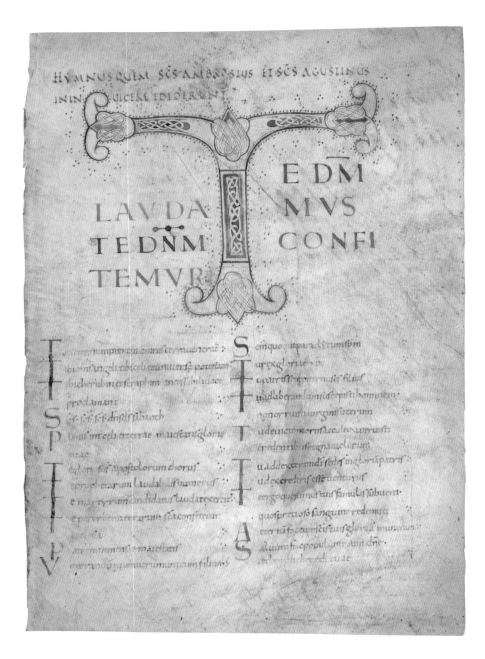

Decorated Initial T

Leaf from a psalter, recto
Northern Italy, third quarter
of the ninth century
Leaf: 30.3 × 21.3 cm (11 15/16 × 8 3/8 in.)
Ms. Ludwig VIII 1; 83.MK.92

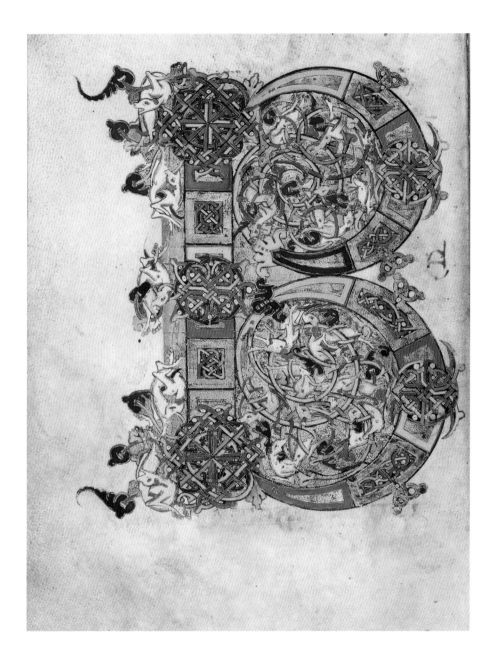

Inhabited Initial B

*Montecassino Breviary, fol. 140v
and detail*
Montecassino, 1153
Leaf: 19.2 × 13.2 cm (7 9/16 × 5 3/16 in.)
Ms. Ludwig IX 1; 83.ML.97

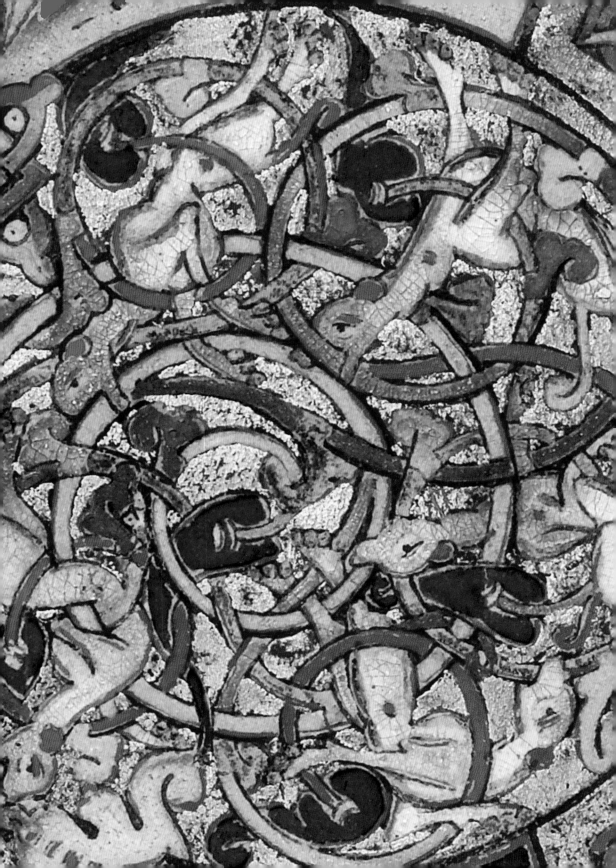

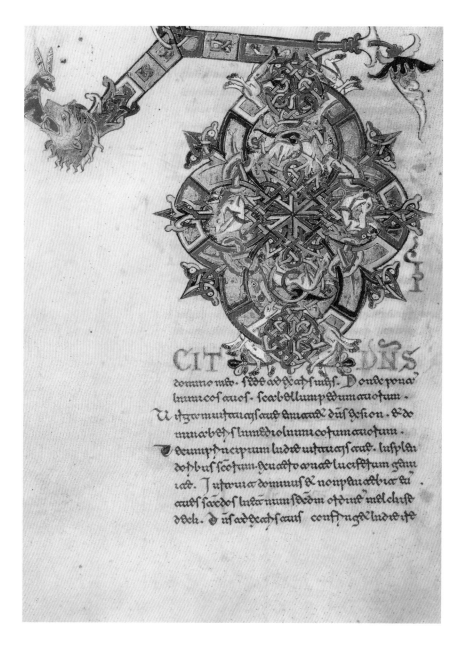

CIT ... DNS
domino meo. sede ad dextris meis. Donec ponam
inimicos tuos. scabellum pedum tuorum.
Uirgam uirtutis tuae emittet dns sesion. et do
minaberis in medio inimicorum tuorum.
tecum principium in die uirtutis tuae. in splen
doribus scotum. ex utero ante luciferum genu
ite. Iurauit dominus et non penitebit eu
tu es sacerdos in eternum secundum ordinem melchise
dech. Dns ad dextris tuis. confrngit in die ire

Inhabited Initial D

Montecassino Breviary, fol. 212v

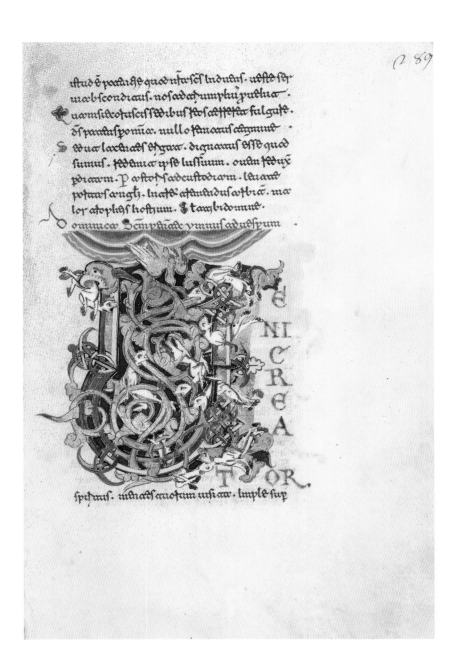

Initial V: The Descent of the Holy Spirit

Montecassino Breviary, fol. 289

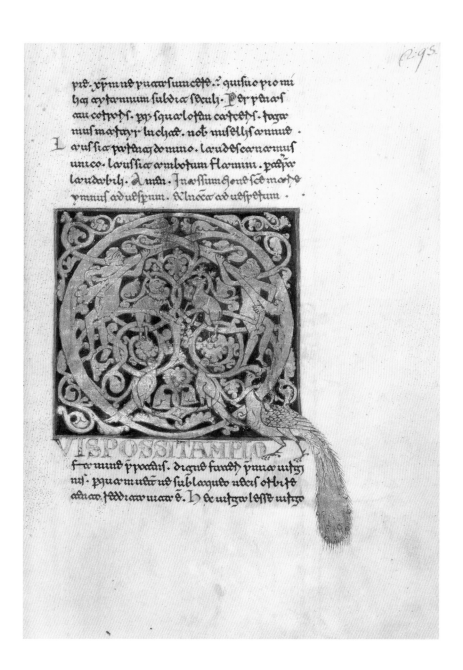

Inhabited Initial Q

Montecassino Breviary, fol. 295

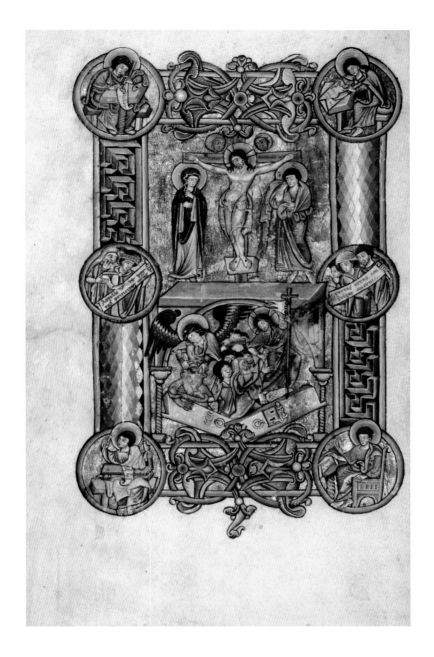

The Crucifixion and the Descent into Limbo

New Testament, fol. 191v
Sicily, late twelfth century
Leaf: 24.6 × 16.2 cm (9 $\frac{11}{16}$ × 6 $\frac{3}{8}$ in.)
Ms. Ludwig I 5; 83.MA.54

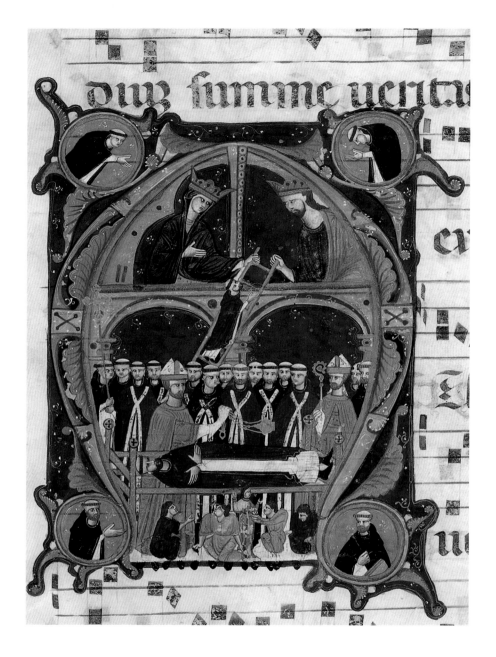

Bolognese Illuminator of the First Style | Initial M: The Death of Saint Dominic

Leaf from an antiphonal, recto (detail)
Bologna, about 1265
Leaf: 52.5 × 37.3 cm (20 11/16 × 14 11/16 in.)
Ms. 62; 95.MS.70

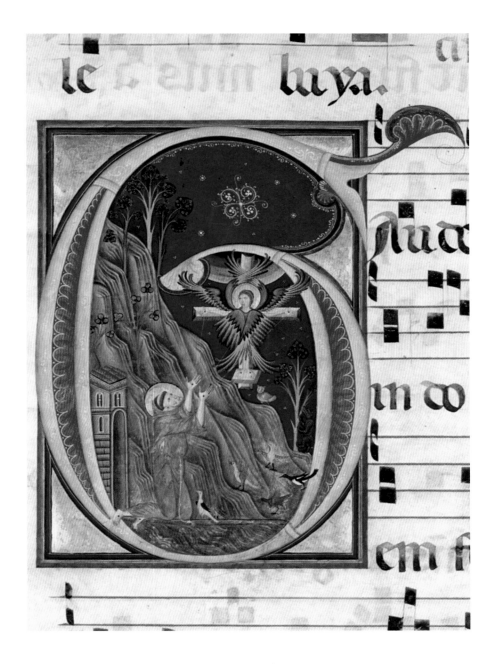

Rinaldo da Siena | Initial G: The Stigmatization of Saint Francis

Leaf from a gradual, verso (detail)
Siena, about 1275
Leaf: 52.9 × 37.2 cm (20 $^{13}/_{16}$ × 14 $^{5}/_{8}$ in.)
Ms. 71; 2003.15

Initial P: Saint Paul with a Bishop Giving a Letter to a Messenger

Bible, fol. 501
Bologna, about 1265–80
Leaf: 37.5 × 24.8 cm (14 ¾ × 9 ¾ in.)
Ms. Ludwig I 11; 83.MA.60

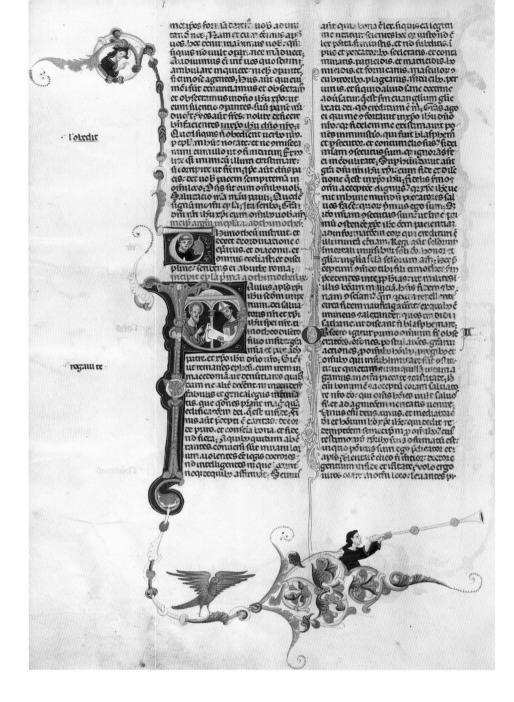

Initial P: Saint Paul Giving a Letter to a Bishop

Bible, fol. 505v

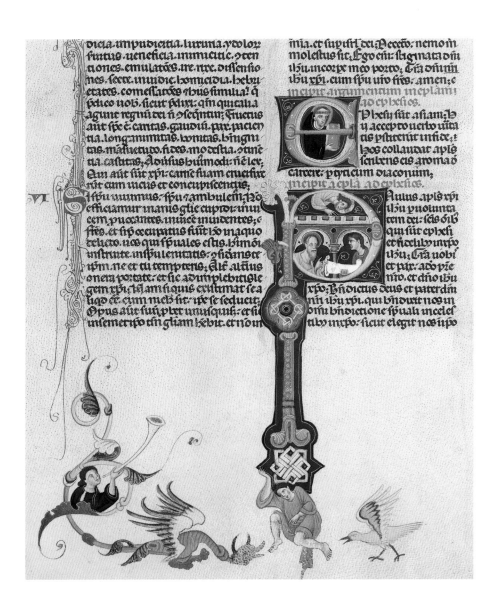

Initial P: Saint Paul Giving a Letter to a Messenger

Bible, fol. 499 (detail)

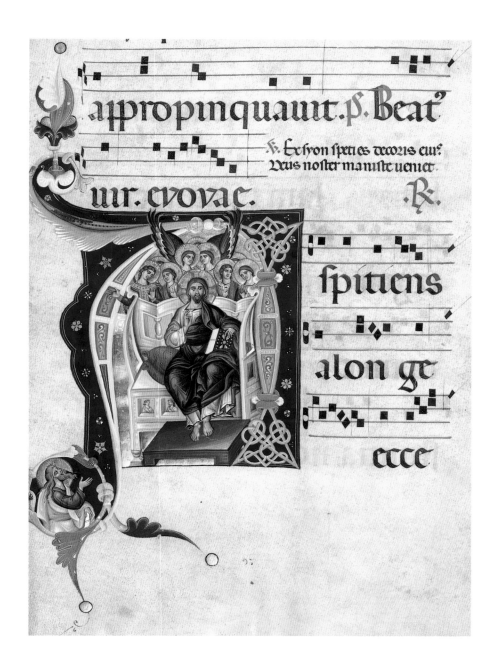

Master of Gerona | Initial A: Christ in Majesty

Antiphonal, fol. 2 (detail)
Bologna, late thirteenth century
Leaf: 58.3 × 40.2 cm (22 $\frac{15}{16}$ × 15 $\frac{13}{16}$ in.)
Ms. Ludwig VI 6; 83.MH.60

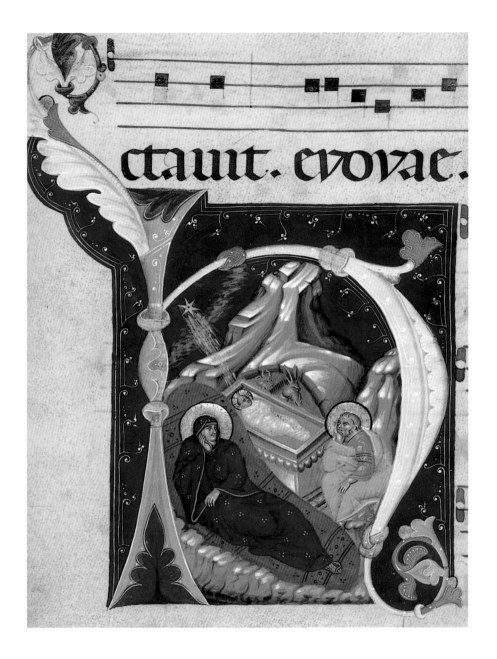

Master of Gerona | Initial H: The Nativity

Antiphonal, fol. 94 (detail)

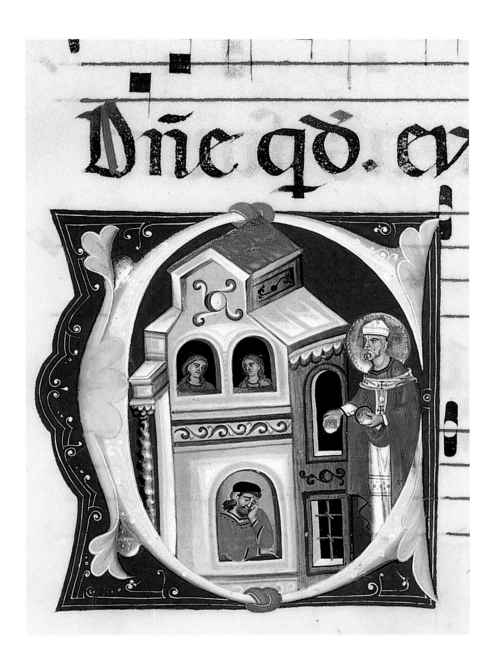

Master of Gerona | Initial C: Saint Nicholas

Antiphonal, fol. 171v (detail)

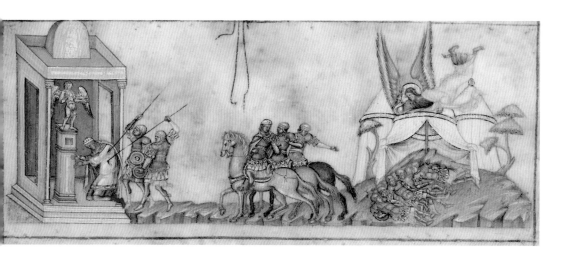

The Assassination of Sennacherib

Leaf 1 from a book of
Old Testament prophets
Sicily, about 1300
Cutting: 7.3 × 16.5 cm (2 ⅞ × 6 ½ in.)
Ms. 35; 88.MS.125

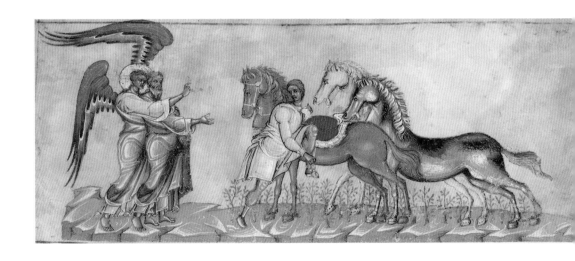

The Vision of Zechariah

Leaf 2 from a book of
Old Testament prophets
Cutting: 7.3 × 17.5 cm (2 ⁷⁄₈ × 6 ⁷⁄₈ in.)

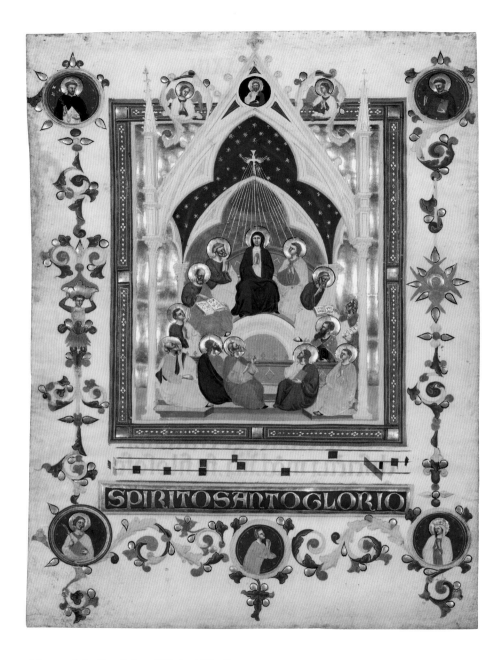

Master of the Dominican Effigies | The Pentecost

Leaf from the Laudario of the
Company of Sant'Agnese, verso and detail
Florence, about 1340
Leaf: 43 × 31.7 cm (16 ¹⁵/₁₆ × 12 ½ in.)
Ms. 80; 2003.106

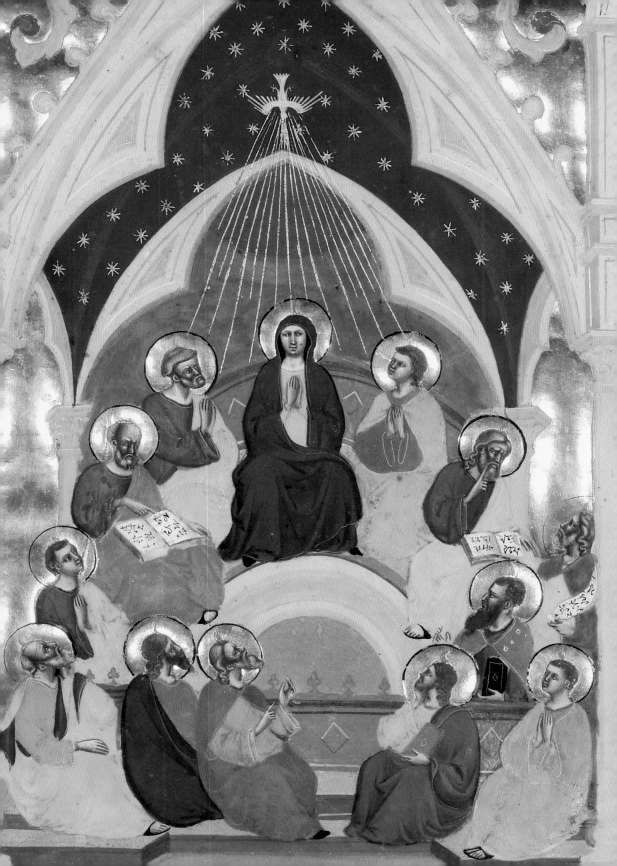

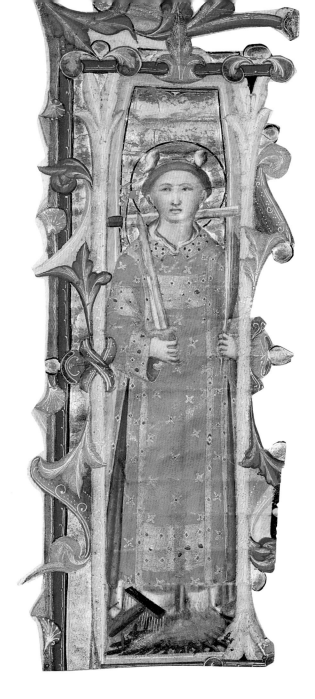

Lippo Vanni | Initial I: A Martyr Saint

Historiated initial from an antiphonal (detail)
Siena, third quarter of the fourteenth century
Cutting: 30.2 × 11.4 cm (11⅞ × 4½ in.)
Ms. 53; 93.MS.38

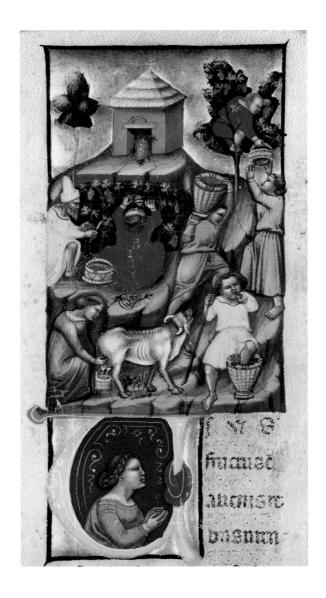

Attributed to the Illustratore | Harvest Scene

Cutting from Justinian,
New Digest (Digestum novum)
Bologna, about 1340
Cutting: 14.4 × 7.6 cm (5 ¹¹⁄₁₆ × 3 in.)
Ms. 13; 85.MS.213

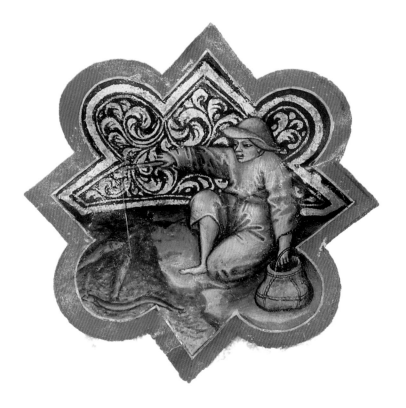

Master of the Brussels Initials | A Man Fishing

Missal, fol. 1v (detail)
Bologna, between 1389 and 1404
Leaf: 33 × 24 cm (13 × 9 7/16 in.)
Ms. 34; 88.MG.71

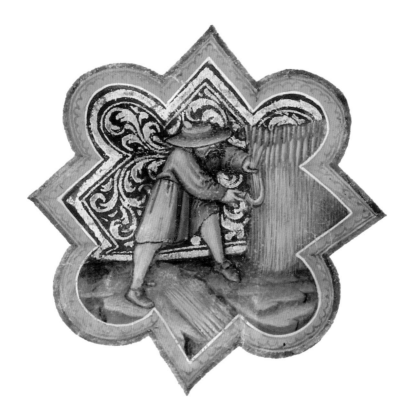

Master of the Brussels Initials | A Man Cutting Grain

Missal, fol. 3v (detail)

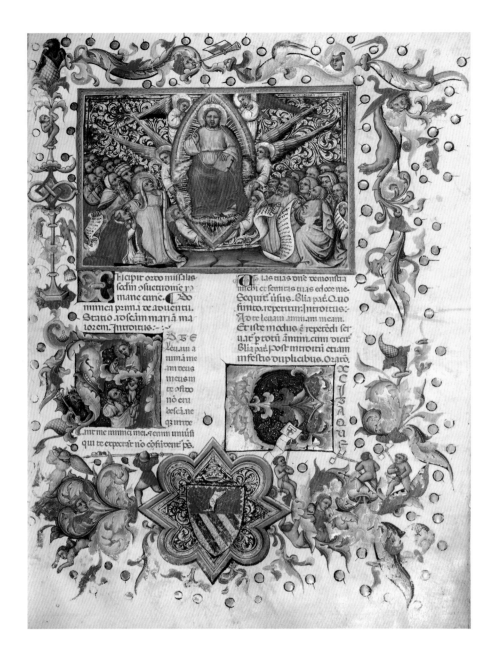

**Master of the Brussels Initials | Christ in Majesty; Initial A:
A Man Lifting His Soul to God**

Missal, fol. 7

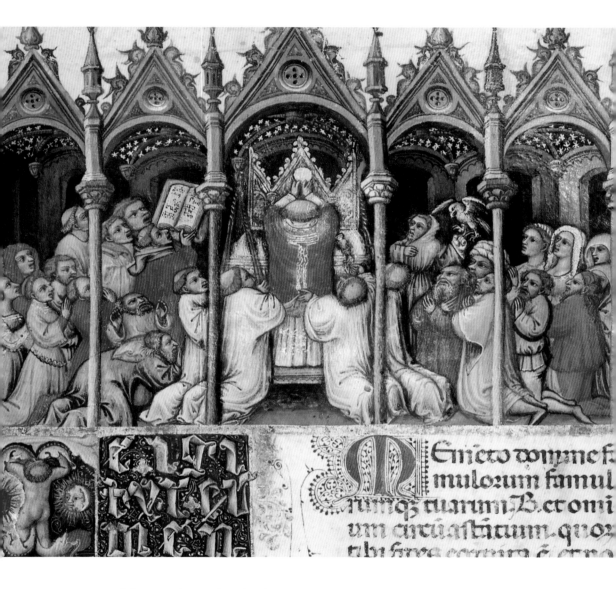

Master of the Brussels Initials | The Elevation of the Host

Missal, fol. 130 (detail)

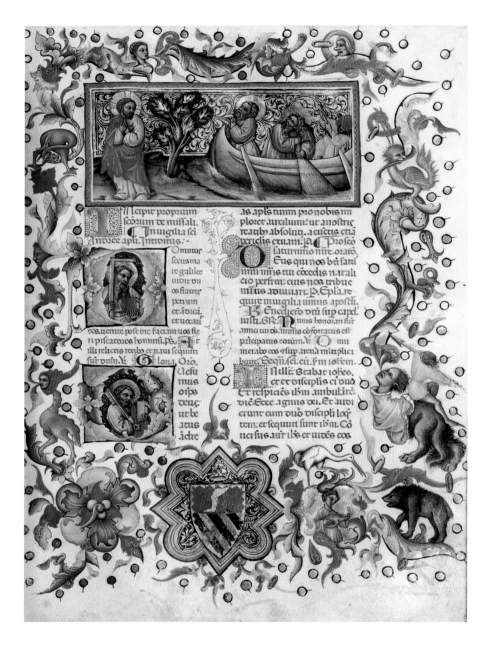

**Master of the Brussels Initials | The Calling of Saints Peter and Andrew;
Initial D: Saint Andrew; Initial Q: Saint Peter**

Missal, fol. 172a and detail

fortatus est

O mni

na mltiplica

. fm iohem.

bat iohes.

plis ei duo

ambulate

xi. Et audi

scipli loq

nt ihm. Có

uidés cos

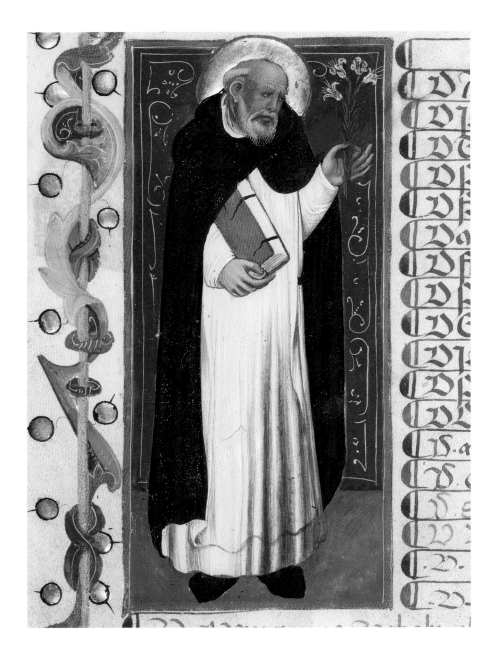

Niccolò da Bologna | Saint Dominic

Leaf from a register of the
Shoemaker's Guild, recto (detail)
Bologna, about 1386
Leaf: 35 × 24.5 cm (13 ¾ × 9 ⅝ in.)
Ms. 82; 2003.113

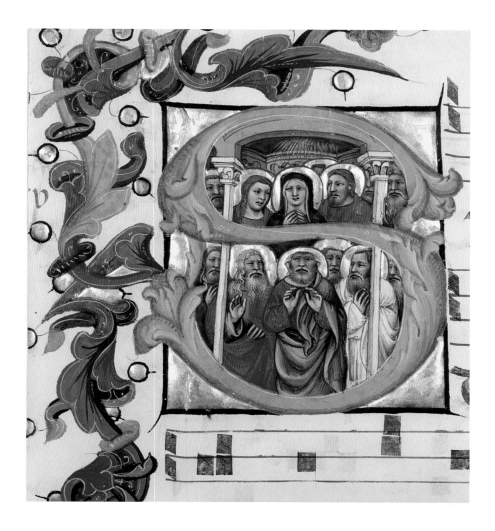

Niccolò da Bologna | Initial S: The Pentecost

Cutting from a choir book
Bologna, about 1392–1402
Cutting: 21.6 × 21 cm (8½ × 8¼ in.)
Ms. 86; 2004.48

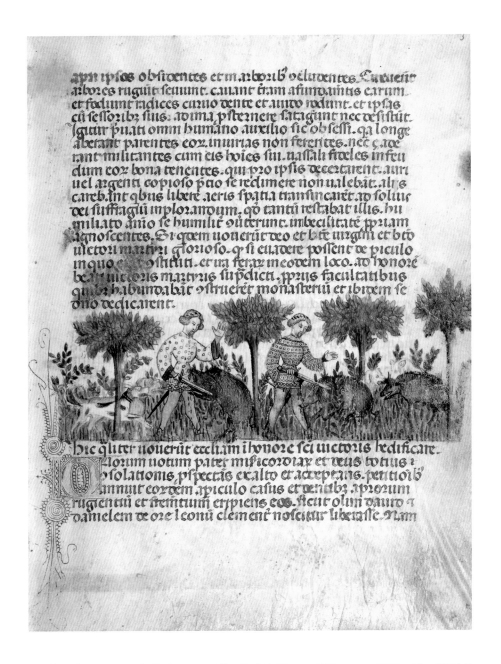

Attributed to Anovelo da Imbonate or His Circle | Aimo and Vermondo Killing Two Wild Boars

Legend of the Venerable Men Aimo
and Vermondo (Legenda Venerabilium
Virorum Aymonis et Vermondi), *fol. 3*
Milan, about 1400
Leaf: 25.6 × 18.4 cm (10 $\frac{1}{16}$ × 7 $\frac{1}{4}$ in.)
Ms. 26; 87.MN.33

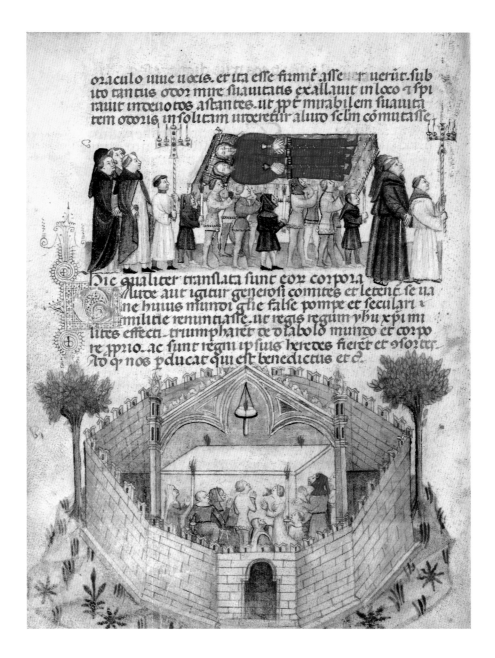

Attributed to Anovelo da Imbonate or His Circle | The Translation of Aimo and Vermondo;
The People of Milan Praying at the Altar Where Aimo and Vermondo Are Buried

Legend of the Venerable Men Aimo
and Vermondo, *fol. 5v*

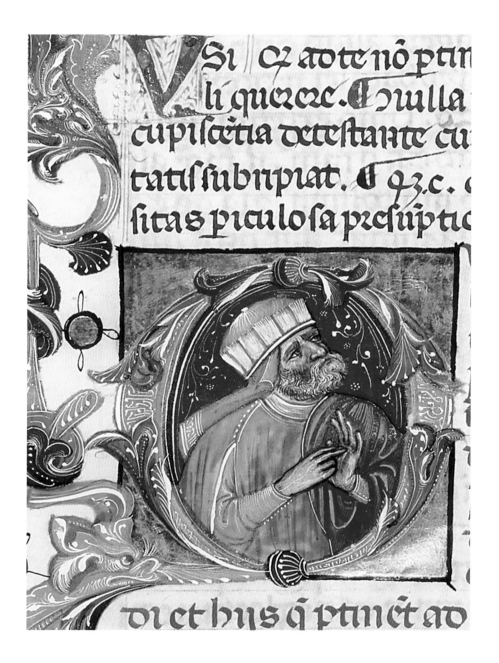

Cristoforo Cortese | Initial Q: Bust Portrait of a Man

Heremias de Montagnone, Compendium
moralium notabilium, *fol. 147 (detail)*
Venice, early fifteenth century
Leaf: 36.8 × 26 cm (14½ × 10¼ in.)
Ms. Ludwig XIV 8; 83.MQ.167

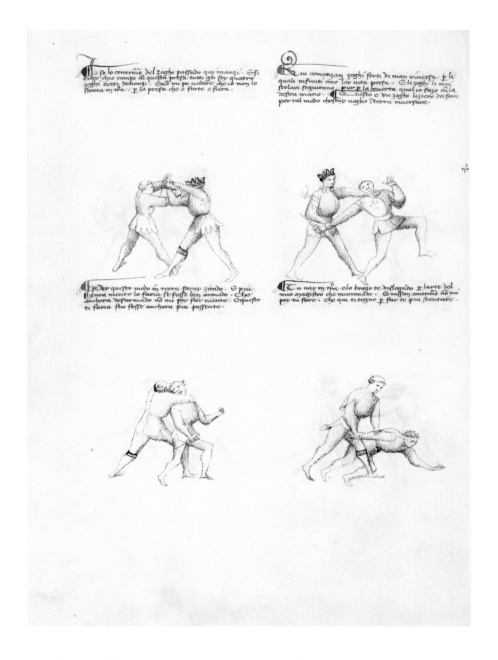

Fiore Furlan dei Liberi da Premariacco | Combat with a Dagger

The Flower of Battle (Fior di Battaglia),
fol. 13v
Northern Italy, about 1410
Leaf: 27.9 × 20.6 cm (11 × 8 ⅛ in.)
Ms. Ludwig XV 13; 83.MR.183

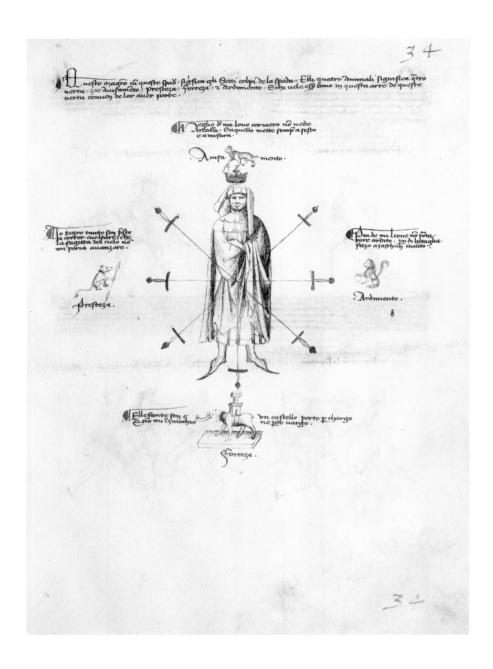

Aiming Foints on the Body

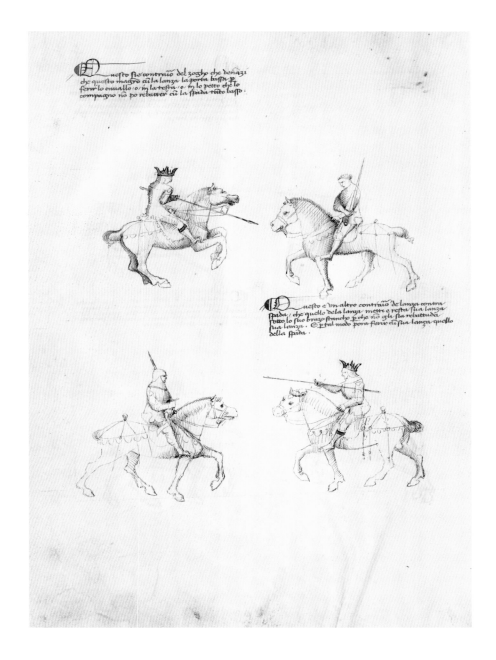

Questo fio contrario del zogho che denanzi
che questo magro cu la lanza la porta bassa p
ferir lo cavallo o in la testa o in lo petto che lo
compagno no po rebatter cu la spada tuto basso

Questo e un altro contrario de lanza contra
spada, che quello dela lanza mette e resta sua lanza
sotto lo suo brazo stancho p che no gli sia rebattuda
sua lanza. E pal modo pora ferir cu sua lanza quello
della spada.

Equestrian Combat with Sword

The Flower of Battle, fol. 44v

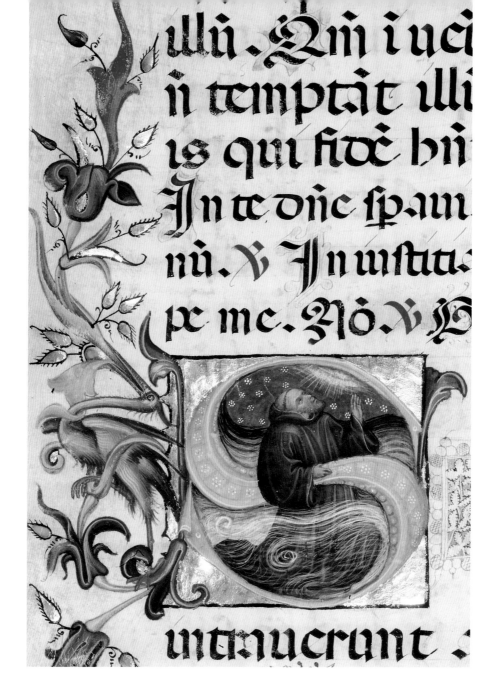

Initial S: Benedictine Monk in a Swirling Sea

Leaf 2 from a noted breviary (detail)
Northeastern Italy, about 1420
Leaf: 46.5 × 34.6 cm (18 5/16 × 13 5/8 in.)
Ms. 24; 86.ML.674

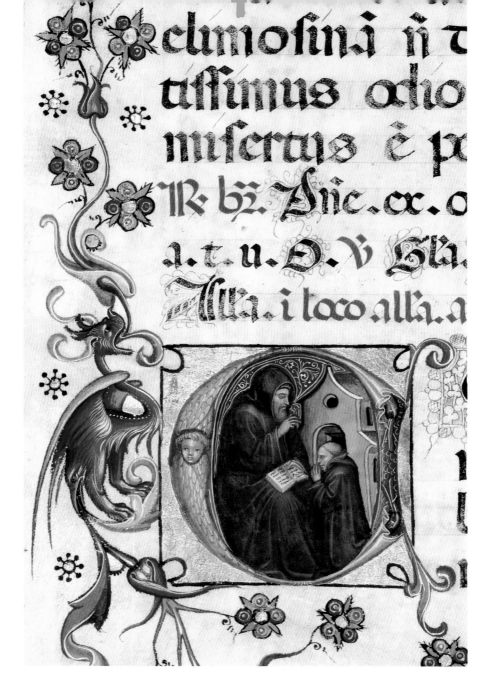

Initial C: Saint Benedict Blessing Maurus

Leaf 4 from a noted breviary (detail)

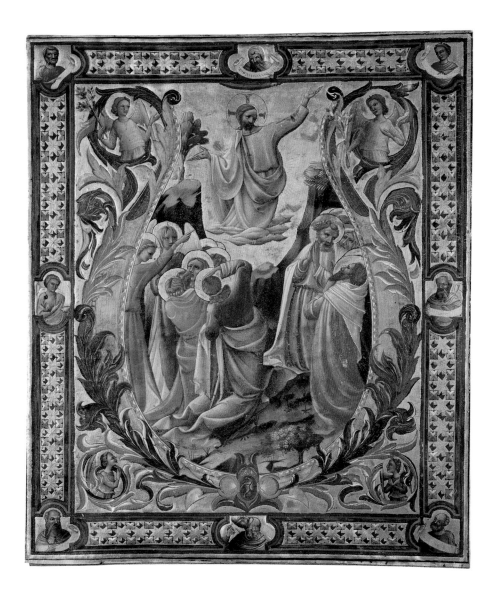

Designed by Lorenzo Monaco; completed probably by Zanobbi Strozzi and Battista di Biagio Sanguini | Initial V: The Ascension

Cutting from a gradual and detail
Florence, about 1409 (designed);
about 1423–24 (completed)
Cutting: 40.2 × 32.4 cm (15 ¹³⁄₁₆ × 12 ¼ in.)
Ms. 78; 2003.104

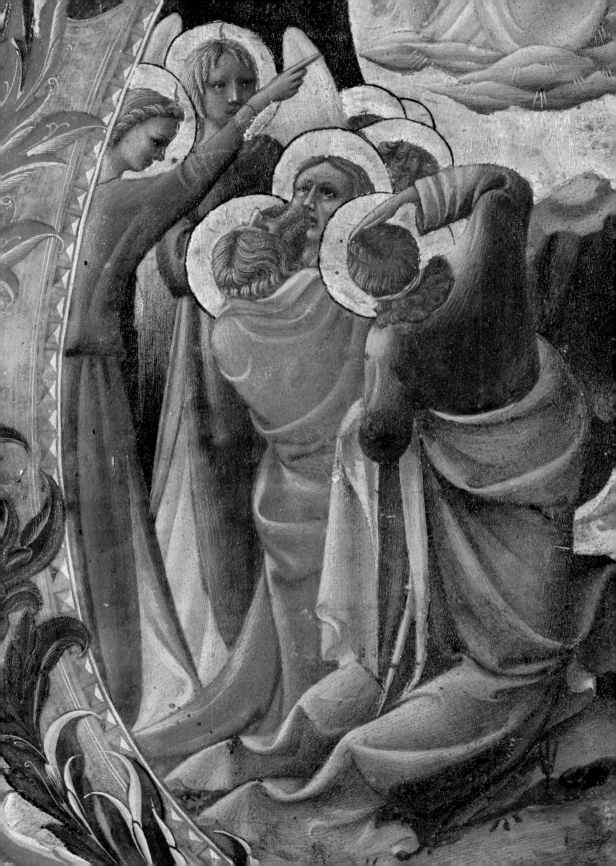

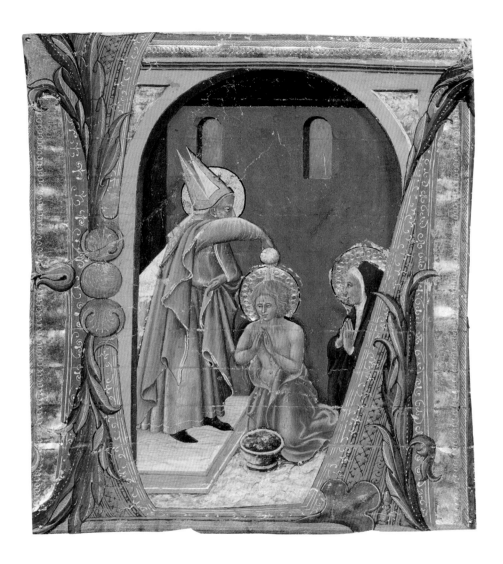

Master of the Osservanza | Initial L: The Baptism of Saint Augustine Witnessed by Saint Monica

Historiated initial from a choir book
Siena, about 1430
Cutting: 18.7 × 16.2 cm (7⅜ × 6⅜ in.)
Ms. 39; 90.MS.41

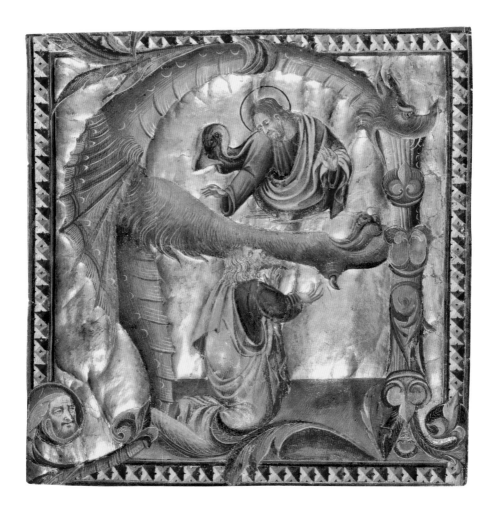

Giovanni di Paolo | Initial A: Christ Appearing to David

Historiated initial from a gradual
Siena, about 1440
Cutting: 20 × 18.6 cm (7⅞ × 7⁵⁄₁₆ in.)
Ms. 29; 87.MS.133

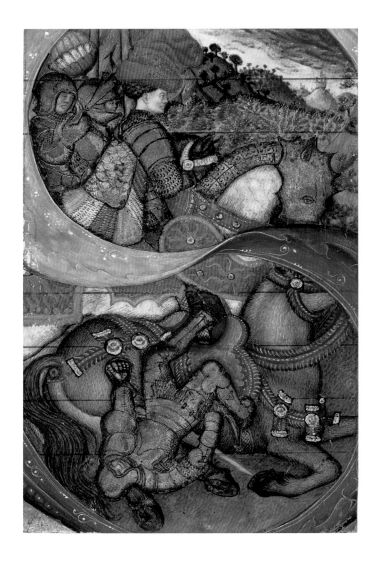

**Attributed to Pisanello and the Master of Antiphonal Q
of San Giorgio Maggiore | Initial S: The Conversion of Saint Paul**

Historiated initial from a gradual
Probably northern Italy, about 1440–50
Cutting: 14.1 × 8.9 cm (5 ⁹/₁₆ × 3 ½ in.)
Ms. 41; 91.MS.5

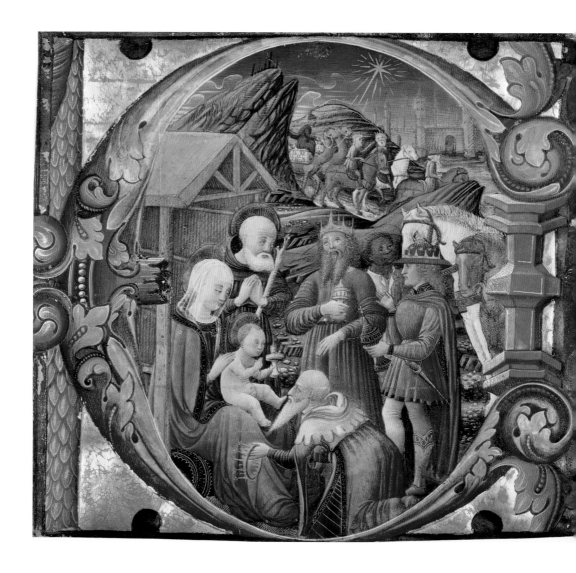

Franco dei Russi | Initial E: The Adoration of the Magi

Cutting from a choir book
The Veneto, 1470s
Cutting: 15 × 15.7 cm (5 ⁷⁄₈ × 6 ³⁄₁₆ in.)
Ms. 83; 2003.114

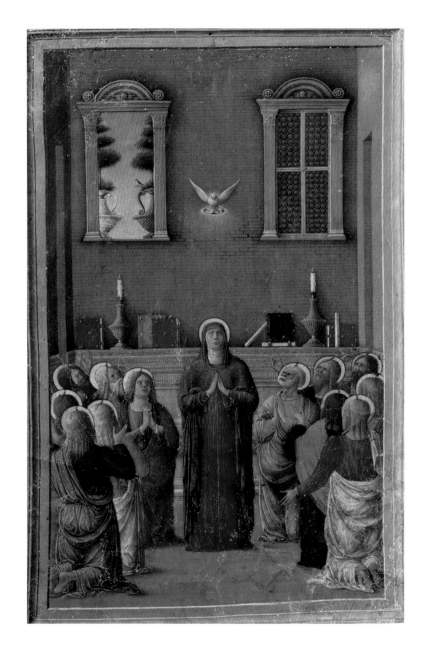

Girolamo da Cremona | The Pentecost

*Miniature from a devotional or
liturgical manuscript*
Probably Mantua, about 1460–70
Cutting: 20.2 × 12.9 cm ($7^{15}/_{16}$ × $5^{1}/_{16}$ in.)
Ms. 55; 94.MS.13

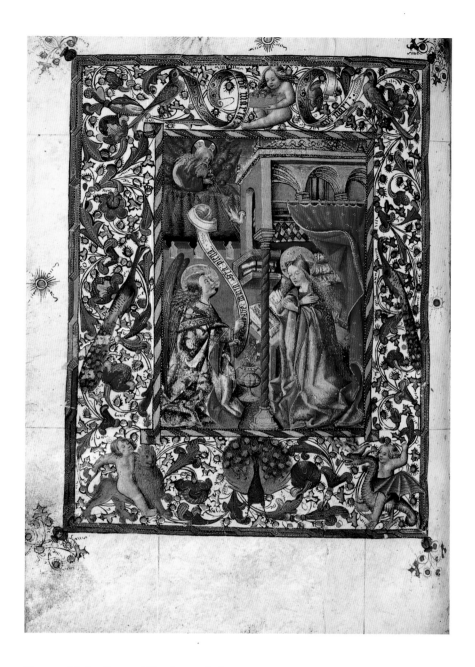

Master of Saint George | The Annunciation

Book of hours, fol. 250v
Naples, about 1460
Leaf: 17.1 × 12.1 cm (6¾ × 4¾ in.)
Ms. Ludwig IX 12; 83.ML.108

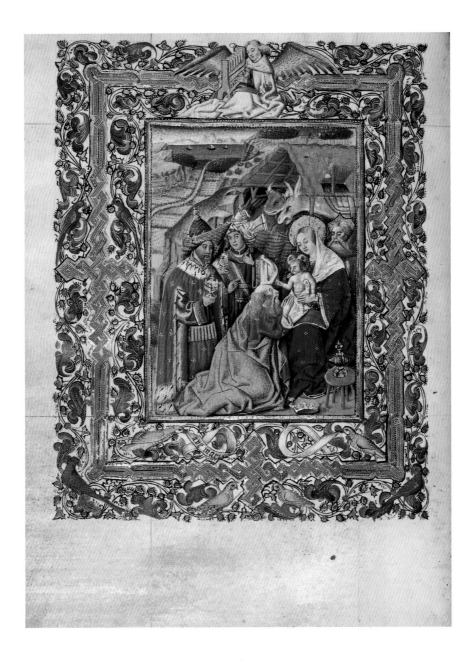

Master of Saint George | The Adoration of the Magi

Book of hours, fol. 256v

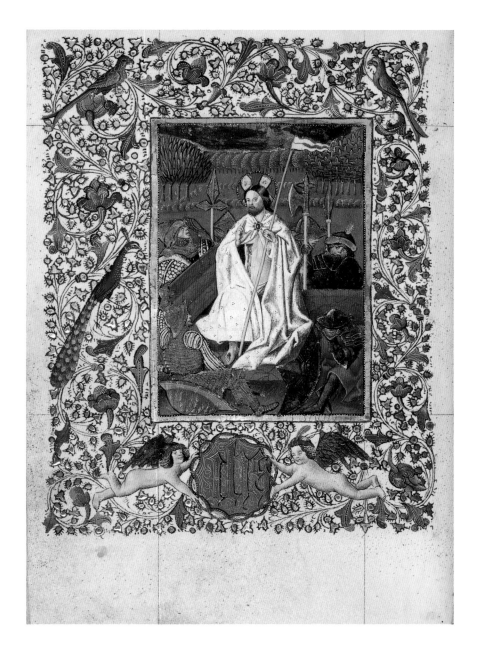

Master of Saint George | The Resurrection

Book of hours, fol. 259v

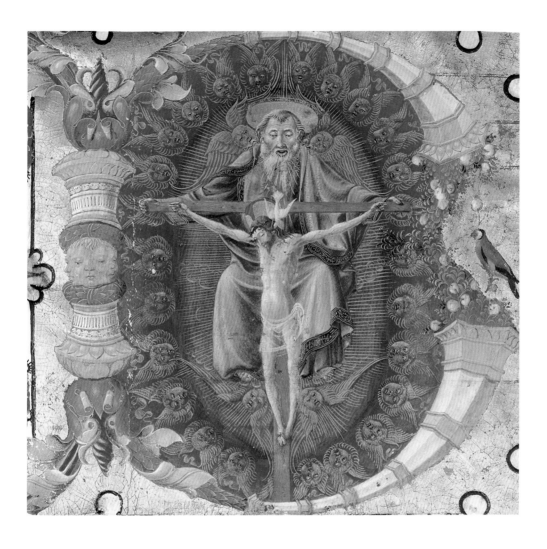

Taddeo Crivelli | Initial B: The Trinity

Cutting from a gradual
Ferrara, about 1460–70
Cutting: 16 × 16 cm (6 ⁵⁄₁₆ × 6 ⁵⁄₁₆ in.)
Ms. 88; 2005.2

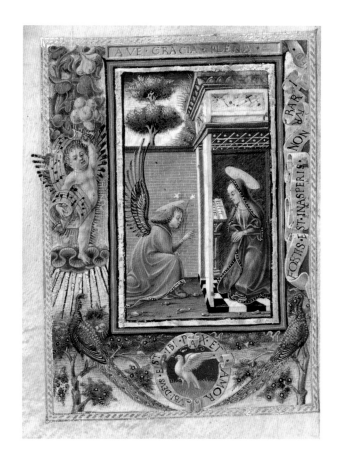

Taddeo Crivelli | The Annunciation

Gualenghi-d'Este Hours, fol. 3v
Ferrara, about 1469
Leaf: 10.8 × 7.9 cm (4¼ × 3⅛ in.)
Ms. Ludwig IX 13; 83.ML.109

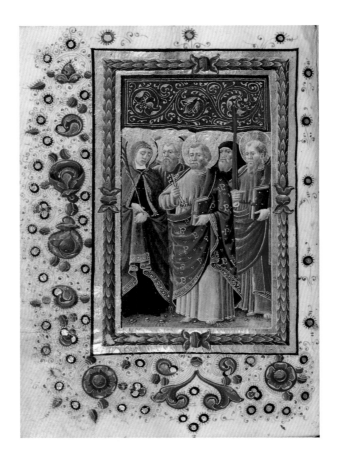

Guglielmo Giraldi | All Saints

Gualenghi-d'Este Hours, fol. 159v

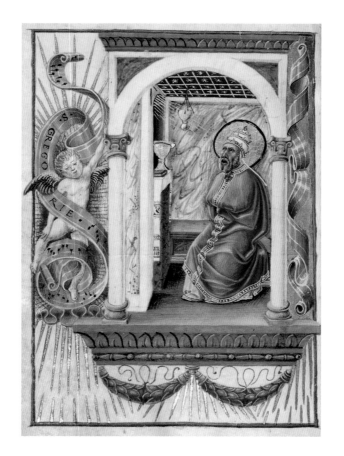

Taddeo Crivelli | **Saint Gregory**

Gualenghi-d'Este Hours, fol. 172v

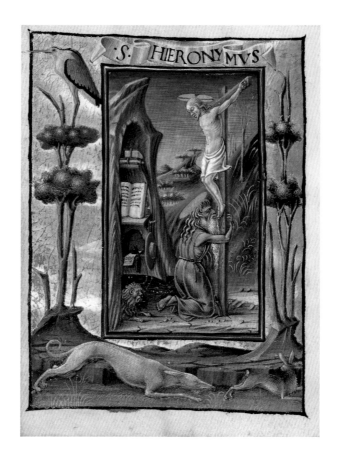

Taddeo Crivelli | Saint Jerome in the Desert

Gualenghi-d'Este Hours, fol. 174v

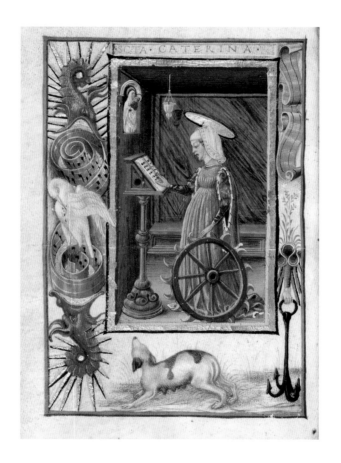

Taddeo Crivelli | Saint Catherine of Alexandria

Gualenghi-d'Este Hours, fol. 187v

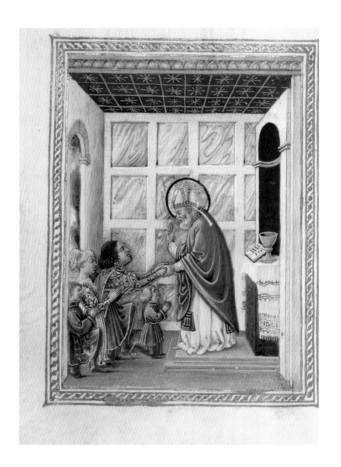

Taddeo Crivelli | Saint Bellinus Celebrating Mass with Andrea Gualengo,
Orsina d'Este, and Children

Gualenghi-d'Este Hours, fol. 199v

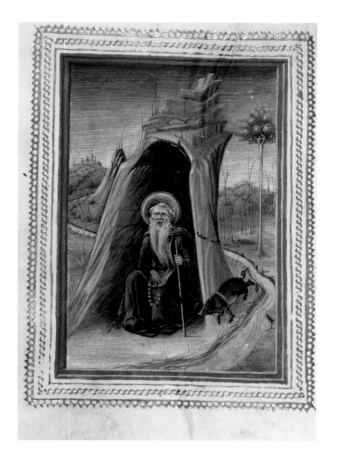

Taddeo Crivelli | Saint Anthony Abbot

Gualenghi-d'Este Hours, fol. 204v

Decorated Text Page

Gaius Julius Caesar, Commentary on
the Gallic Wars (De Bello Gallico) *and
other texts, fol.* 1v
Florence, about 1460–70
Leaf: 32.7 × 23 cm (12 ⅞ × 9 ¹⁄₁₆ in.)
Ms. Ludwig XIII 8; 83.MP.151

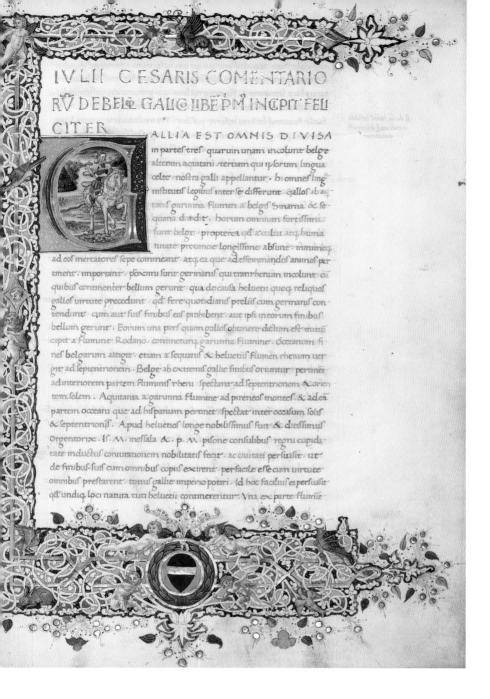

Attributed to Francesco d'Antonio del Chierico | Initial G: Julius Caesar on Horseback

Fol. 2

Decorated Text Page

Lactantius, Divine Institutions (Divinae
institutiones) *and other texts, fol. 1v*
Florence, about 1460
Leaf: 32.9 × 22.1 cm (12 ¹⁵⁄₁₆ × 8 ¹¹⁄₁₆ in.)
Ms. Ludwig XI 1; 83.MN.120

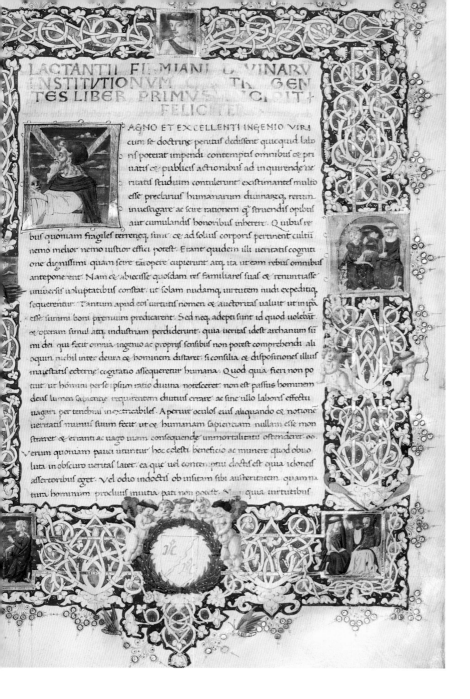

The Fiesole Illuminator | Initial M: Portrait of Lactantius

Fol. 2

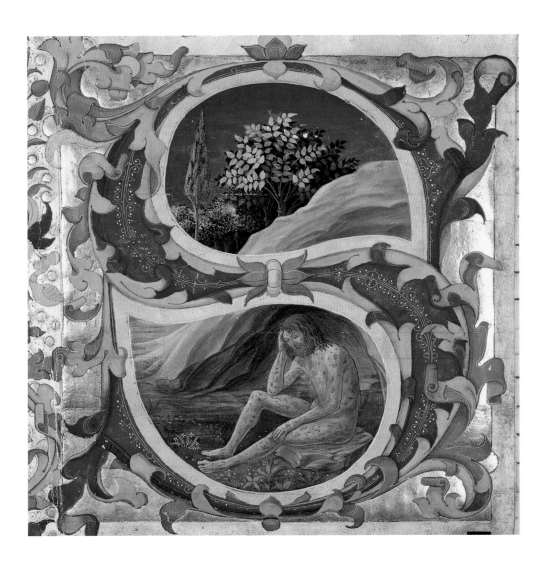

Francesco d'Antonio del Chierico | Initial S: Job

Cutting from a choir book
Florence, third quarter of
the fifteenth century
Cutting: 21 × 19 cm (8 ¼ × 7 ½ in.)
Ms. 74; 2003.88

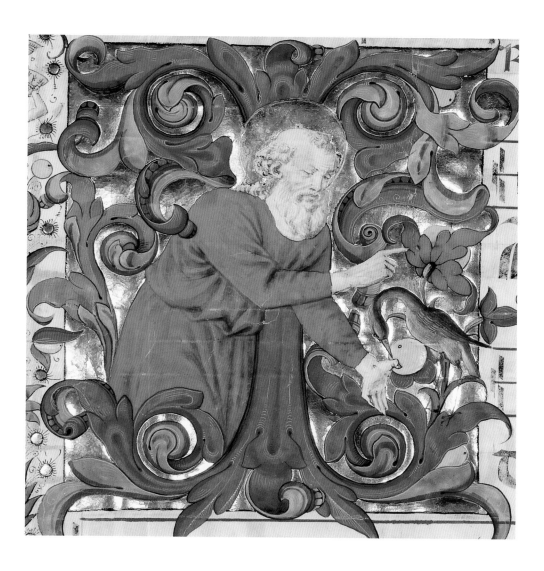

Francesco d'Antonio del Chierico | Initial I: God the Father Blessing

Bifolium from an antiphonal (detail)
Florence, early 1460s
Leaf: 57.7 × 40 cm (22 ¹¹⁄₁₆ × 15 ¾ in.)
Ms. 84; 2003.115

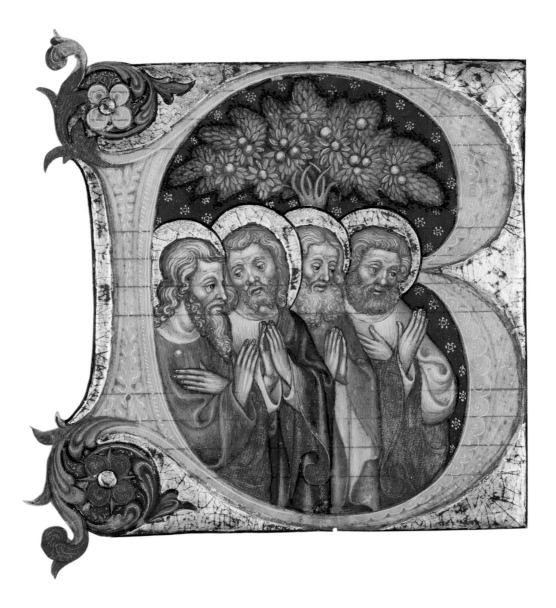

Olivetan Master | Initial B: Four Saints

Cutting from a choir book
Lombardy, about 1450
Cutting: 20.6 × 19.1 cm (8 ⅛ × 7 ½ in.)
Ms. 75; 2003.89

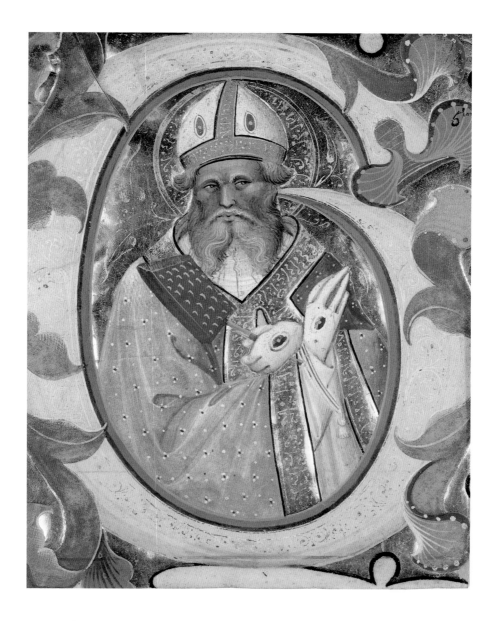

Master of the Murano Gradual | Initial G: Saint Blaise

Historiated initial from a gradual
Venice, about 1450–60
Cutting: 15.7 × 12 cm (6 ¹⁄₁₆ × 4 ¾ in.)
Ms. 73; 2003.87

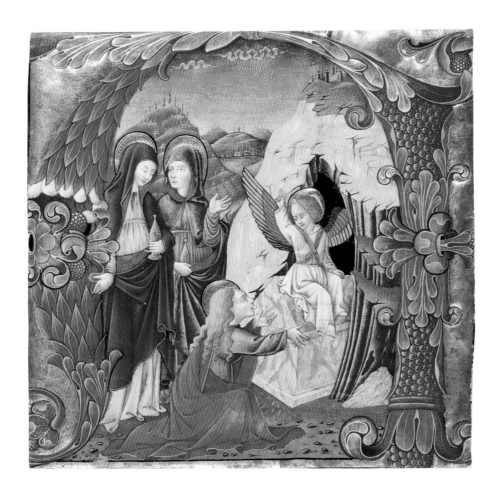

Bartolomeo Rigossi da Gallarate | Initial A: The Women at the Tomb

Historiated initial from an antiphonal
Lombardy, about 1465
Cutting: 15.1 × 14.6 cm (5 $\frac{15}{16}$ × 5 $\frac{3}{4}$ in.)
Ms. 47; 93.MS.2

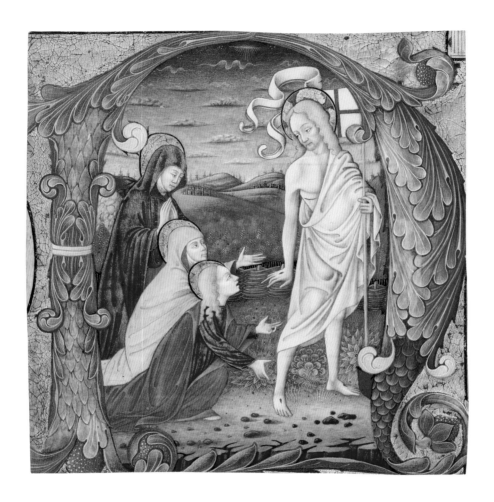

Bartolomeo Rigossi da Gallarate | Initial N: Christ Appearing to the Marys

Historiated initial from an antiphonal
Lombardy, about 1465
Cutting: 15.1 × 14.6 cm (5 $\frac{15}{16}$ × 5 $\frac{3}{4}$ in.)
Ms. 49; 93.MS.8

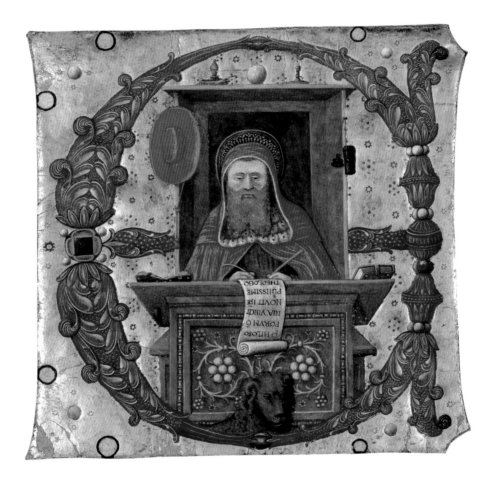

Initial E: Saint Jerome in His Study

Historiated initial from a choir book
Lombardy, about 1470–80
Cutting: 14.5 × 14 cm (5 $\frac{11}{16}$ × 5 $\frac{1}{2}$ in.)
Ms. 76; 2003.90

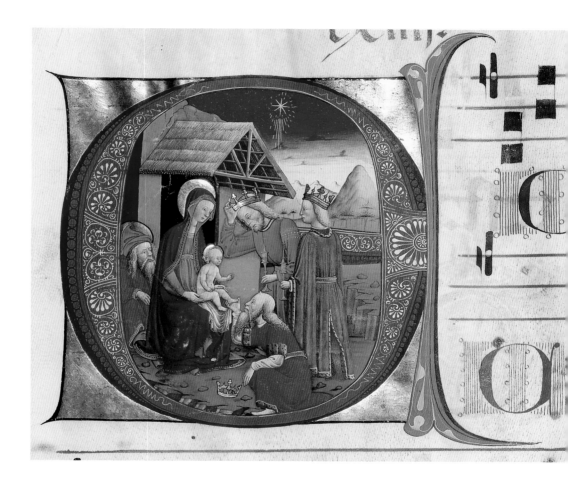

Initial E: The Adoration of the Magi

Gradual, fol. 64 (detail)
Northern Italy, about 1460–80
Leaf: 60.3 × 44 cm (23 ¼ × 17 ⁵/₁₆ in.)
Ms. Ludwig VI 2; 83.MH.85

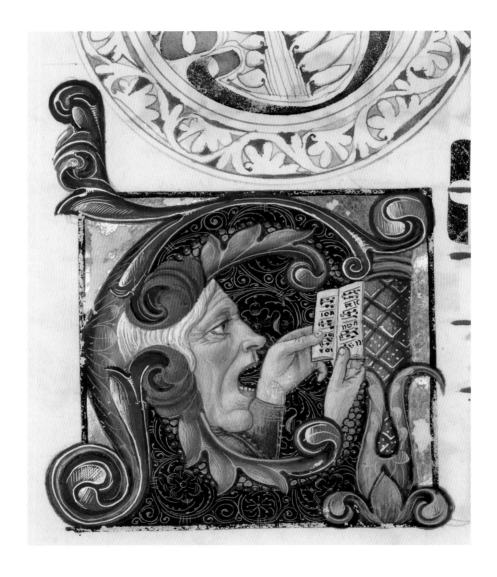

Inhabited Initial A

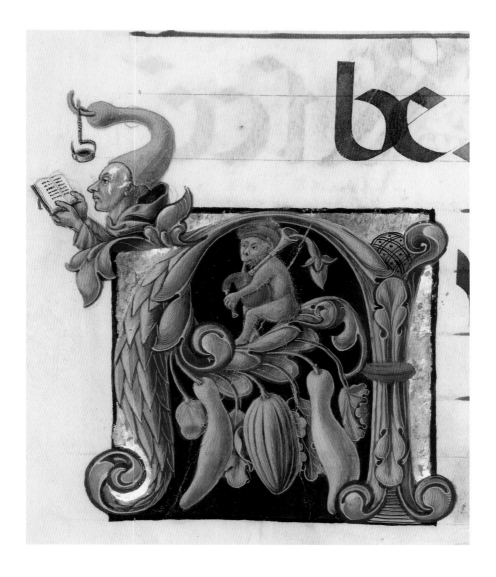

Inhabited Initial A

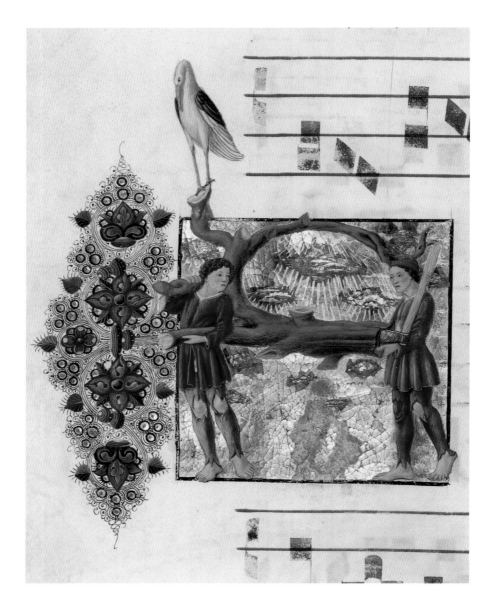

Inhabited Initial A

Gradual, fol. 160v (detail)

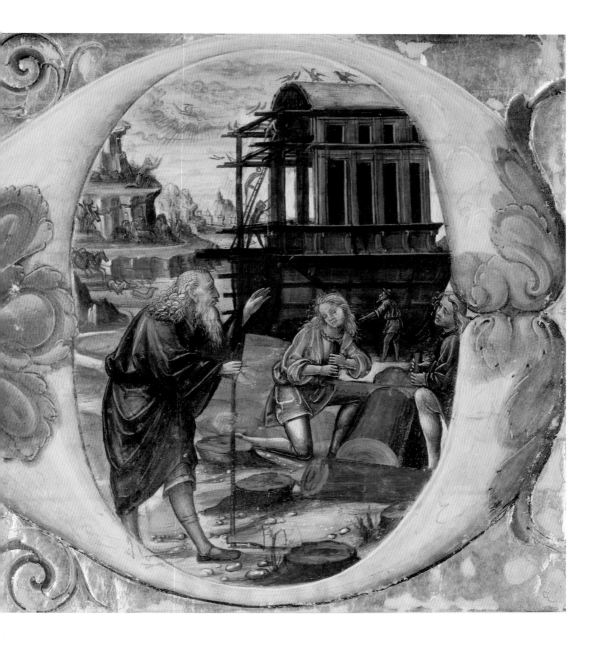

Master B. F. | Initial D: Noah Directing the Construction of the Ark

Historiated initial from an antiphonal
Lombardy, about 1490–1510
Cutting: 16.8 × 17 cm (6 ⅝ × 6 ¹¹⁄₁₆ in.)
Ms. 56; 94.MS.18

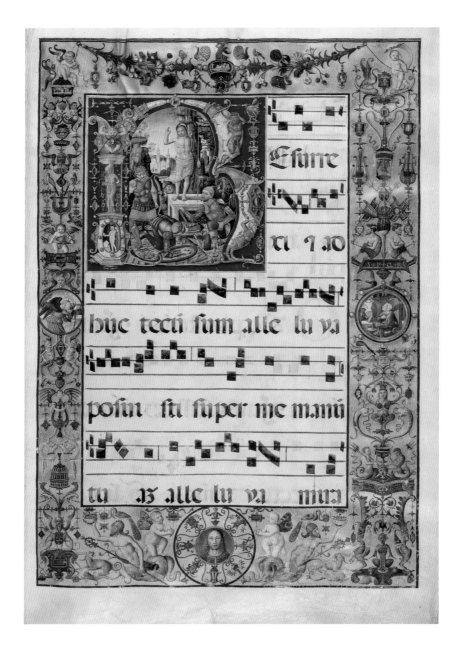

Antonio da Monza | **Initial R: The Resurrection**

Gradual, fol. 16 and detail
Rome, late fifteenth or early
sixteenth century
Leaf: 64.1 × 43.5 cm (25 ¼ × 17 ⅛ in.)
Ms. Ludwig VI 3; 83.MH.86

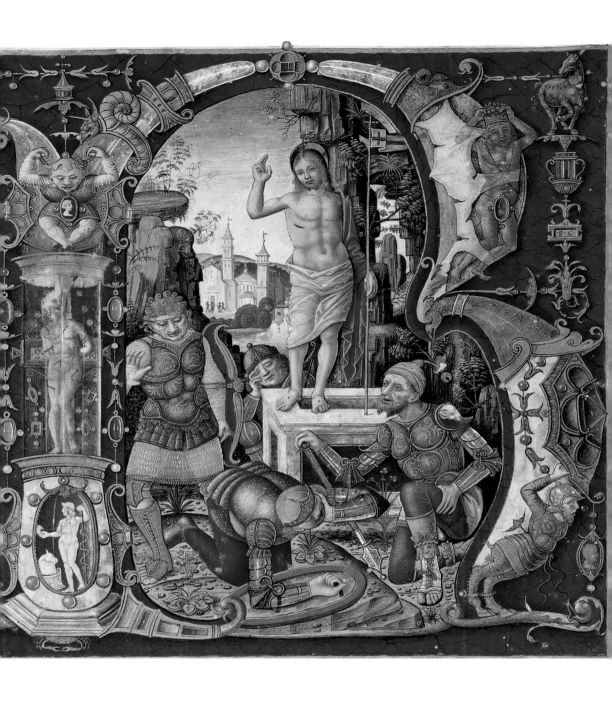

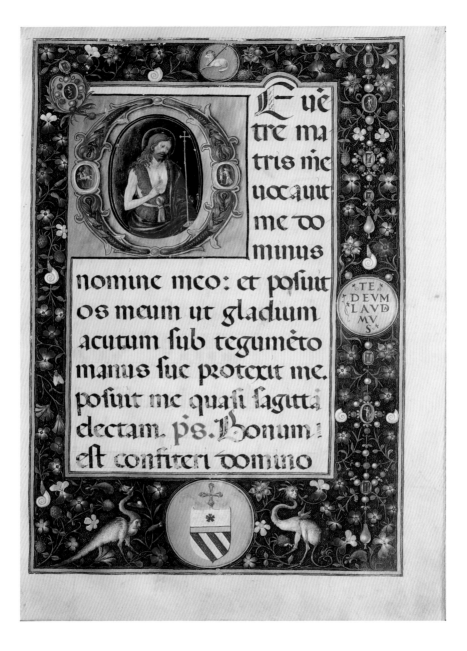

Matteo da Milano | Initial O: Saint John the Baptist

Missal, fol. 4
Rome, about 1420
Leaf: 33.6 × 23.4 cm (13 ¼ × 9 ¼ in.)
Ms. 87; 2004.65

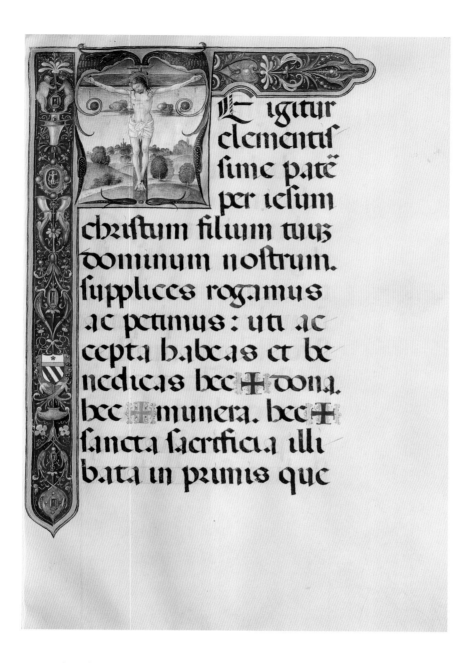

Te igitur clementis sime patē per iesum christum filium tuuz dominum nostrum. supplices rogamus ac petimus : uti ac cepta habeas et be nedicas hec ✠ dona. hec ✠ munera. hec ✠ sancta sacrificia illi bata in primis que

Matteo da Milano | Initial T: The Crucifixion

Missal, fol. 27

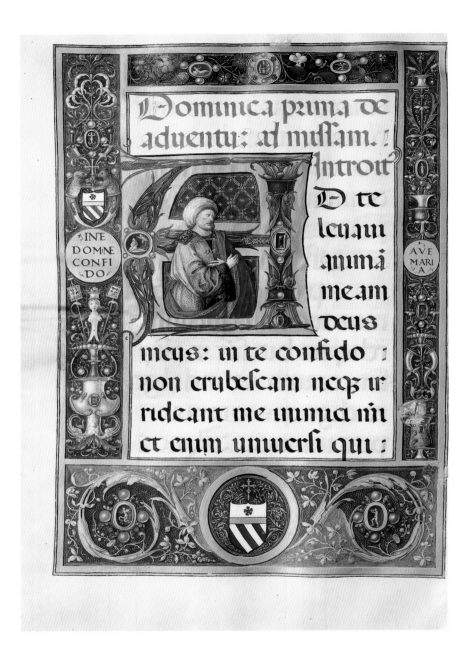

Matteo da Milano | **Initial A: King David**

Missal, fol. 52v

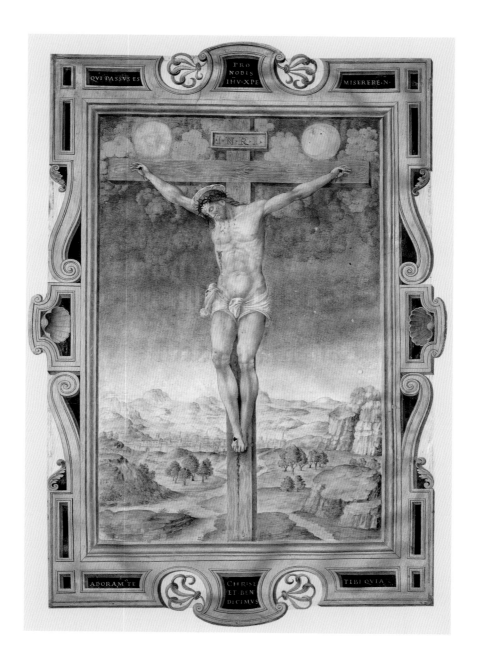

Vincent Raymond | The Crucifixion

Miniature from a missal
Rome, about 1545
Detached miniature: 37.2 × 26 cm
(14 ⅝ × 10 ¼ in.)
Ms. 85; 2003.116

© 2005 The J. Paul Getty Trust
Getty Publications
1200 Getty Center Drive, Suite 500
Los Angeles, California 90049-1682

Christopher Hudson, Publisher
Mark Greenberg, Editor in Chief

Ann Lucke, Managing Editor
Vickie Sawyer Karten, Designer
Amita Molloy, Production Coordinator

Photography and digital imaging supplied by Chris Allen Foster and
Michael Smith of Getty Imaging Services.

Color separations by Professional Graphics Inc., Rockford, Illinois

Printed and bound by CS Graphics Pte. Ltd., Singapore

Library of Congress Cataloging-in-Publication Data

Kren, Thomas, 1950–
 Italian illuminated manuscripts in the J. Paul Getty Museum / Thomas Kren, Kurt Barstow.
 p. cm.
 ISBN-13: 978-0-89236-820-4 (pbk.)
 ISBN-10: 0-89236-820-9 (pbk.)
 1. Illumination of books and manuscripts, Italian. 2. Illumination of books and manuscripts,
Medieval—Italy. 3. Illumination of books and manuscripts, Renaissance—Italy. 4. Art—California—
Los Angeles. 5. J. Paul Getty Museum. I. Barstow, Kurt, 1965– II. J. Paul Getty Museum. III. Title.

ND3159.K74 2005
745.6'7'094507479494—dc22 2004028795

FRONT COVER: Girolamo da Cremona, The Pentecost (detail, plate p. 44)
BACK COVER: Designed by Lorenzo Monaco; completed perhaps by Matteo Torelli
and Battista di Biagio Sanguini, Initial V: The Ascension (detail, plate p. 38)
FRONTISPIECE: Matteo da Milano, Initial A: King David (detail, plate p. 76)
PAGE IV: Master of Gerona, Initial A: Christ in Majesty (detail, plate p. 13)
PAGE VI: Attributed to Pisanello and the Master of Antiphonal Q of San Giorgio
Maggiore (detail, plate p. 42)